IMAGINE THAT... THE HISTORY OF FILM REWRITTEN

MICHAEL SELLS

Published in the UK in 2013 by
Icon Books Ltd, Omnibus Business Centre,
39–41 North Road, London N7 9DP
email: info@iconbooks.net
www.iconbooks.net

Sold in the UK, Europe and Asia
by Faber & Faber Ltd, Bloomsbury House,
74–77 Great Russell Street,
London WC1B 3DA or their agents

Distributed in the UK, Europe and Asia
by TBS Ltd, TBS Distribution Centre, Colchester Road,
Frating Green, Colchester CO7 7DW

Distributed in India by Penguin Books India,
11 Community Centre, Panchsheel Park,
New Delhi 110017

Distributed in South Africa by
Book Promotions, Office B4, The District,
41 Sir Lowry Road, Woodstock 7925

Distributed in Australia and New Zealand
by Allen & Unwin Pty Ltd,
PO Box 8500, 83 Alexander Street,
Crows Nest, NSW 2065

Distributed in Canada by
Penguin Books Canada,
90 Eglinton Avenue East, Suite 700,
Toronto, Ontario M4P 2Y3

ISBN: 978-184831-575-4

Typeset in New Baskerville by Simmons Pugh
Printed and bound in the UK by Clays Ltd, St Ives plc

Contents

Imagine that...

Some of history's greatest stories are the tales of what might have been. The agonising missed chances, the harrowingly close shaves, the vital complications that affected a major outcome – the course of history is a precarious one. Seemingly insignificant incidents can have the largest unforeseen impacts.

Scientists have pondered whether the flap of a butterfly's wings on one continent could lead to a tornado on another, and these chains of cause and effect remain fascinating to us. In this book and the others in the series I take a look at those moments where the smallest tweak would have caused history to pan out very differently.

Hence the title, *Imagine That* ...

Michael Sells

Imagine that ...
The farmers of southern California revolt against plans for an aqueduct ... and Chicago becomes the new home of American cinema

Perfectly formed and immaculately decorated, one could be forgiven for thinking that the Hollywood hills were part of an elaborate set design. They have provided the backdrop to many a film, becoming more famous than the works produced in the studios of the city below. The world of shattered flashbulbs, cemented hand prints and red carpets has long dominated the landscape of downtown Hollywood, but this has not always been the case. Before cinema was king and Hollywood became synonymous with glamour and success, the Gabrielino tribe roamed the cactus-covered expanse that was La Nopalera.

With no overarching town planning, the future form of La Nopalera (Spanish for 'the cactus patch') was uncertain.

The undeveloped terrain could just as easily have become a small, condensed town as the sprawling metropolis it is today. In fact, when in 1887 the area was officially renamed Hollywood, a small town was what this picturesque spot seemed destined to become. As was commonplace during the settling of America, the unpopulated land had been divided into plots, or ranchos, and sold off to willing buyers. Mr H.H. Wilcox purchased a large rancho upon which he planned to build a holiday home for himself and his wife. Mrs Daeida Wilcox named the house 'Hollywood' but the term soon came to refer to the entire rancho. Daeida raised the required funds for key town amenities including churches and schools, and before long the rancho had become a thriving town.

Of course Daeida Wilcox did not raise funds for a colossal movie business. The town's defining feature came almost entirely by chance. The climate and glorious surroundings of the region made it an ideal location for American film crews. In 1907, forced west by the grey skies of home, a Chicago-based production company struggling to complete a weather-stricken shoot stumbled upon the Wilcox rancho. The hills did not yet bear the iconic Hollywood sign and the city centre was still an understated suburban stretch, but the revolution was set to begin.

Within five years Hollywood was home to a wealth of film companies. It offered a relative haven compared to New York and other major cities which were subject to increasingly oppressive equipment regulations. Filmmaking at the time was dominated by Kinetoscope technology. This system

EDISON
PROJECTING
KINETOSCOPE

It is unequalled for HOME ENTERTAINMENT. The improved machine is now so simple that an amateur can operate it. Projects both *moving pictures* and *stereopticon slides* on the screen. The mechanism is turned by hand. If electric current is not in your town or in your house, we give you choice of other ways of making the light. Our catalogues give complete information and lists of moving pictures. ADDRESS KINETOSCOPE DEPARTMENT C EDISON M'F'G CO., ORANGE, N. J., U. S. A.

of capturing pictures was devised by Thomas Edison's General Electric and was subject to surprisingly lax patenting, in a lapse of commercial thinking uncharacteristic of the inventor. A complete lack of overseas patents meant foreign inventors and manufacturers were able to upgrade and improve upon Edison's design before selling it back to the American market on import.

However, once Edison realised his oversight, he began to threaten legal action against those film crews using his designs. The East Coast was leading the way in cinema at the turn of the century with New York as its driving force, but with Edison based in New Jersey and growing increasingly litigious, the region soon became untenable for filmmakers and a mass exodus began.

As Hollywood emerged as the new home of cinema, the diminutive town found itself swelling with a creative new populace. Suddenly, Hollywood was no longer agricultural land but rather a bustling town complete with some of the finest restaurants and clubs in the whole of America. However, the transition was far from seamless; the area's farming community revolted against the shift in the town's make-up, feeling that the new residents were being unfairly prioritised. The town's authorities did little to assuage their concerns. As the opportunity to become the home of American cinema grew more apparent, plans were swiftly devised

to grasp the chance by making the town more accessible. In 1908, a year after the Chicago film company first happened upon Hollywood, blueprints for the Owens Valley Aqueduct were drawn up and construction began immediately. The project was completed in 1913, signalling the beginning of the end for Hollywood's farmers.

The construction of the aqueduct created thousands of jobs but, when the work was completed, those jobs disappeared along with thousands more. The water that filled the aqueduct had been diverted from the Owens Valley, sapping vital resources and vastly reducing the farming capacity of the land. Local outrage was palpable and enduring, culminating in a dynamite attack on the controversial structure

in 1924. The long-running unrest came to be known as the California Water Wars. By the time of the disgruntled residents' explosive act of sabotage it was already too late; the town's film industry was booming and agriculture was forever destined to take a back seat. The landmarks of Tinseltown were beginning to take shape.

With nearby Los Angeles growing at an equally rapid rate, real estate in southern California was serious business. Prime locations and neighbourhoods were marked up and sold with ease. The sector was as intensely competitive for sellers as it was for potential tenants, so agencies and developers took to increasingly inventive sales techniques to compete. In 1923, Messrs Tracy Shoults and Sidney Woodruff, a pair of Los Angeles property developers, constructed an exciting new hillside community for aspirational Californians. Very much in the mould of a Mediterranean village, the idyllic complex would have been attractive all on its own. Shoults and Woodruff, however, felt the need to make everyone aware of their new venture. They erected an eye-catching sign; thirteen letters, each one 45 feet tall, on the side of the Hollywood hills. They simply spelled out 'HOLLYWOODLAND'.

It was the name of their attractive community, but came to mean so much more. Initially intended to stand for just over a year, the sign was so popular that it soon became an irreplaceable motif upon the hillside, but it wasn't cheap. High yearly maintenance costs, for both the sign and the accompanying lighting system, led to a compromise in 1949. The Los Angeles Parks Department promised to take on the duty

of maintaining the sign, provided that the last four letters were removed. Having long outgrown the community it was built to promote, it the sign finally stood as an all-inclusive icon for Hollywood and its glamorous exports. It was the icing on the cake, the tinsel on the town, but for the local farmers it was the final insult. What was once just a sales billboard now confirmed the extinction of their trade in the region. Hollywood was the undisputed home of showbiz.

Hollywood, the cradle of American cinema, has become the unrivalled global powerhouse of blockbusters. On the face of it, the formula was simple enough – right place, right time, *lots* of money. But that's only scratching the surface of the birth of Hollywood. The home of cinema could so easily have pitched up elsewhere and had it done so, the canon of works that has emerged from the hills would have been altered beyond recognition.

The start of the 20th century was a time of great techno-logical progress and America was shaped by the new meth-ods. The relative youth of the nation meant that cities and states were still forging their identities. Nothing provided a stronger identity, nor higher employment, than unique industries and exports. Natural produce and services came to characterise and define individual communities and states throughout the 1800s; California was known for being rich in fruit fields and assorted crops. The clamour for such

an identity, for something to put states 'on the map', meant that many other states and cities would have welcomed the movie scene enthusiastically and universally.

The Water Wars had the potential to derail the growth of Tinseltown or even to end it. As was seen in the migration of filmmakers from New York following Edison's legal threats, film studios felt no real sense of geographic loyalty. While some controversies can be attractive to exciting art movements, agricultural disputes would probably not have been. Had the residents voiced or demonstrated their objections at an earlier stage then it is highly likely that New York's decamping filmmakers would have given southern California a wide berth and taken up residence in another unsuspecting city.

After Los Angeles, the next most suitable location to provide a home to American cinema was Chicago. Although situated in the eastern half of the country, Chicago was still hundreds of miles from Edison with a buffer zone of several states. What's more it already boasted an impressive local motion picture industry, second only to New York at the time. In fact, it remained a second home to many film studios even after most had relocated to California. However, Chicago was blighted by legal wrangles of its own. Around the time that Hollywood began to boom, Chicago's independent film companies set about overthrowing the monopoly of the industry giants, much to the distaste of the established studios. The disputes centred on loopholes in industry agreements which saw independent studios living beyond their means, creating a perceived imbalance in

The Chicago Association of Commerce
Committee of Investigation on Smoke Abatement
and Electrification of Railway Terminals

MAP OF
CHICAGO
AND VICINITY

Showing Railroad Yards
And Connecting Routes

Scale

Office of Chief Engineer Chicago Dec. 1913

favour of the minor players who faced comparatively lesser sanctions than the larger studios. However, with stricter regulation this might not have been an issue. Had Hollywood not been discovered when it was, the amicable agreement reached by Chicago's filmmakers in later years would surely have been hurried by the promise of such a boost to the local industry.

It could easily have happened differently; after all, Hollywood was not chosen deliberately but simply stumbled upon by film crews driving west, following the sun. Of course, this was one element Chicago could not have replicated. With cold winters and humid summers, Chicago was a workable destination but by no means an ideal one. Transport routes

and methods were improving all the while, and it would only have been a matter of time before the sun-swept hills and beaches of Los Angeles were discovered by film crews. The Hollywood hills would undoubtedly still have played host to some of cinema's greatest tales due to the reliability of their climate. Yet with the studios settled in Chicago and Hollywood further advanced as an agricultural power, the backdrop to such tales might have been vastly different.

When cinema arrived in Hollywood, it benefited from a relatively blank canvas. The town was built from scratch, giving new tenants and developers the freedom to build expressive and ambitious buildings. But without a vibrant town to attract new buyers, developments like Hollywood-

land would never have come into existence, and the hills would have remained unadorned by the now-iconic signage as a result. Within a decade or two, such was the speed of growth in America at the time, the freedom to create would arguably have disappeared beneath the vast, ever-expanding orange groves and the region would have developed far more organically. The Owens Valley would still have been home to a thundering river and the entire ecosystem of Hollywood, La Nopalera or whichever name it might have been known by, would have altered dramatically as a result.

Without the burgeoning movie business and resultant urban overhaul, Hollywood could well have come to resemble the more northerly reaches of the state. One of Hollywood's most successful directors, Alfred Hitchcock (pictured left), took a shine to northern California when he moved to the area from his native England. Widely regarded as one of the greatest filmmakers in history, he used San Francisco and the surrounding area as the setting for most of his films. He often declared his love of northern California and its vast vineyards. Canadian actor Hume Cronyn once recounted Hitchcock saying: 'When the day's work is

done, we go out to the vineyards and squeeze the grapes through our hair.' His attraction to the area was borne out of far more than just recreational activities.

Perversely, California without the Hollywood film industry could well have provided Hitchcock with a far greater array of possible set locations. The untamed expanses and coastland that featured in so many of his films would have been preserved state-wide. That said, had American cinema been based in Chicago, he might never have had the chance to explore the Californian hills as extensively as he did, robbing him of the iconic settings of his most influential works. His 1963 psychological thriller *The Birds* has come to be heralded as one of cinema's finest and most eerie works. Bodega Bay, California, formed the backdrop and played as pivotal a role in the film as the cast or even the birds. Unlike Hollywood, Bodega Bay was commonly swathed in fog, and with bare hillsides surrounding it Hitchcock found a per-

fectly bleak location for his tale. However, Chicago shares this type of foggy climate and so Hitchcock might well have found himself filming *The Birds* elsewhere. Such alterations in possible set locations would have affected so many of Hollywood's great films.

The American film industry led the way throughout the 20th century, due partly to the nation's wealth and partly to great inventors such as Thomas Edison. The building blocks were in place for its bold artistic minds to prosper; it was simply a matter of where. American motion pictures were projected in cinemas across the globe, and this would have been no different if they had come from outside Los Angeles. What would have changed is the overarching style and content of the films. Classics such as *Gone with the Wind* (1939) and more recently *Pretty Woman* (1990) would have been stripped of their well-known settings and uprooted to alternate locations. And had American cinema been based

in Chicago then many of the Californian stars and directors we know and love might never have got their chance, the opportunities on their doorstep relocated thousands of miles east. The stars of an industry so dependent on being in the right place at the right time would have had their careers thrown into jeopardy, while Chicago's budding stars could so easily have landed in the lap of fame.

Without cinema at its heart, the landscape of Hollywood and America beyond it would be unrecognisable to us today. The streets of Chicago might have been lined with the concrete handprints of movie stars – only those handprints could belong to the office workers and labourers of years gone by, rather than the esteemed showbiz royalty of Hollywood. Some of the greats might not have come to the fore,

and presently unknown talents would have taken their place. Whether this would have been an improvement or not is anyone's guess, but one thing is certain. Without the Hollywood hills or the Walk of Fame, without the hordes of wannabe movie stars flocking to the streets of LA, the world's view of California would be completely different. The stars of the golden era of cinema would not and could not have dined in Hollywood's eateries and bars. It would still be a land of beauty, but the beautiful vineyards and farmlands would have remained the focus, rather than the beautiful people on the silver screen. There's no telling which unknowns would have become the stars of the Chicago movie scene, but 20th-century cinema would surely have been a very different prospect.

William Randolph Hearst

Imagine that...

William Randolph Hearst succeeds in getting *Citizen Kane* banned ... and movie-goers are deprived of some of the best tales ever told

The British Film Institute was founded in 1933 and a year later took over the now-esteemed *Sight and Sound* magazine. It is a collaboration that has come to provide the most authoritative voice on film and all that surrounds it, not least through the definitive polls they carry out once a decade. These polls, surveying the opinions of critics since 1952 and directors since 1992, have long provided a yardstick against which the film world measures the changing attitudes and values of the industry. The winner of the inaugural critics' poll, Vittorio De Sica's *Ladri di Biciclette* (*Bicycle Thieves*) fell to seventh place a decade later and has since failed to crack the top ten. As a 1948 film it was still fresh in the critics' mind when the 1952 poll was taken, but

the emergence of other great films coupled with the test of time has seen its popularity waver, though it is still revered as one of the greats.

Other films, however, have made a more gradual climb to the peak of cinema, their influence and innovation only becoming clear years later. These films tend to have a more enduring legacy, rather than simply being the flavour of the decade. The film that replaced *Ladri di Biciclette* in 1962 had not even made the top ten a decade earlier, but went on to cement the top spot for the following half-century. This film was Orson Welles' 1941 drama *Citizen Kane*. While the cinematography of *Citizen Kane* may pale alongside that of modern computer-generated blockbusters like *Avatar* (2009), when it first hit the big screen it was like nothing anyone had ever seen before. It was the first major motion picture to popularise the use of deep focus, a cinemato-

graphic technique which kept the entire shot in focus. This meant the scenes had clarity from foreground to back-ground, rather than simply focusing on the characters and blurring their sur-roundings. It made for a much richer visual experi-ence and enabled Welles to use the whole of the shot. Gregg Toland (left),

Orson Welles

Welles' chosen cinematographer, became the first director to achieve real success with deep focus and in doing so he laid the groundwork for America's darkest, most brooding and in many respects most stylish export; film noir.

In addition to this, Welles established a number of filmmaking techniques that are still used today and that made for a slicker, more impressive production. The use of deep focus made it vital that the shots were adequately filled, giving rise to strategic low-angle shots. Filming from the base of a skyscraper or lining up a crowd shot with the tops of heads instead of shooting from above enabled Welles to create illusions of grandeur. It was a revolutionary manipulation of perspective. Add to this Welles' daring new technique of blurring soundtracks – fading in the sounds of the following shot earlier to make for a smoother transition – and the result was a bold advancement of the medium of cinema.

The focus of the storyline, however, held the potential for an altogether different revolution in cinema, one that would have censored Welles' directorial artistry. The film told the

story of Charles Foster Kane, played by Welles himself. Kane is a media mogul presiding over the fictional *New York Inquirer*, a publication he proclaims to be the source of honest, noble journalism

Keystone of the Hearst Newspapers

**TRUTH
JUSTICE
PUBLIC
SERVICE**

Twenty-Eight
HEARST
NEWSPAPERS

Read by more than 20,000,000 people
in 18 Key Cities of the United States...

What a Market for Automobiles
and Automobile Accessories !

New York American	Chicago Herald and Examiner	San Francisco Examiner
New York Evening Journal	Chicago American	San Francisco Call-Bulletin
Albany Times-Union	Washington, D. C., Herald	Oakland Post-Enquirer
Rochester Journal	Washington, D. C., Times	Los Angeles Examiner
Rochester Sunday American	Boston American	Los Angeles Herald
Syracuse Journal	Boston Sunday Advertiser	Wisconsin News (Milwaukee)
Syracuse Sunday American	Detroit Times	Seattle Post-Intelligencer
Atlanta Georgian	Baltimore News	San Antonio Light
Atlanta Sunday American	Baltimore Sunday American	Pittsburgh Sun-Telegraph
	Omaha Bee-News	

but which soon descends into a vehicle for unsubstantiated rumours and lies.

The tale is one of greed and inhumanity presiding under the banner of fiction, but was seen by one particularly powerful gentleman as a direct and unabashed attack on his name and empire.

William Randolph Hearst came to run 28 newspapers across some of America's biggest and most powerful cities. As a result he exerted more power than almost any individual in the country. So when it was brought to Hearst's attention that Welles had produced a film centring on a protagonist very much in his image, he set about using his power to prevent its release. He was a formidable opponent for anyone, even with the studio (RKO Radio Pictures) for Welles to hide behind. Hearst began his battle against the film through official channels. He enlisted the help of Louis B. Mayer, head of Metro Goldwyn Mayer, in his attempt to buy the film out and see it destroyed, as well as launching numerous attacks upon Welles in his papers; but to no avail, as we shall see. Although no official alliance existed between the two, MGM had previously distributed some minor Hearst film productions. Their willingness to act on Hearst's behalf was a result of fear of his power, and the belief that the changes Welles' provocative production threatened to bring about would be wholly negative.

Rumours abounded in the following months and years of underhand plots by Hearst to frame Welles with setups for scandalous photographs but Welles managed to escape with his integrity very much intact, as was evident from the grad-

ual yet emphatic rise of *Citizen Kane* to the top of cinema's shortlists. It was only a decade or so later that it became clear just how vital a film *Citizen Kane* had been and how much Welles had changed the industry. Yet if William Randolph Hearst had succeeded in his efforts then it could have been erased from history, such was his control of the media.

Far more than just 119 minutes of cinema rested upon the outcome of Welles and Hearst's feud. It had the potential to set the precedent for decades to come. If Hearst had won then it would have sent out an emphatic message to filmmakers and other artists that the newspapers were not to be challenged and that print journalism was king. His campaign grew so vitriolic that it would have undoubtedly tempered the ambitions of any other director with hopes of depicting the world of journalism as anything other than idyllic.

In an age without the instant social media platforms that keep modern journalists on their toes, Welles was certainly at a serious disadvantage. The only effective outlets for the 'truth' were the very institutions with which Welles found himself at loggerheads. Censorship was nothing new in Hollywood. In the 1920s, each motion picture produced by a studio in Hollywood was subject to the rules and regulations put in place by the Motion Picture Producers and Distributors of America (MPPDA). Topics and features prohibited

HEARST, THE WIZARD OF OOZE

by this organisation ranged from matters of taste, such as the use of profanity, racism or excessive violence, to subjects that appeared to be banned solely to serve the self-interest of the moviemaking elite. Displays of racism were apparently banned, but so too was the depiction of white people as slaves, along with storylines featuring interracial couples. With an overwhelming majority of white directors, stars and supporting cast, the MPPDA's regulations reflected the makeup of the industry at the time. Black supporting actors often appeared for the sake of realism but very rarely in a speaking role.

But rules are made to be broken. By 1941 the initial regulations of 1920 had been eroded by wily producers managing to contravene the rules without punishment, but a whole new set of taboos had come to the fore. Cinema had grown significantly as a business and the regulations, written or otherwise, now reflected political and propaganda-driven allegiances. This was exemplified in the opposition that faced Welles and RKO Studios: not just Hearst, but Metro Goldwyn Mayer. With hindsight, it is easy to assume that MGM's motives in attacking *Citizen Kane* were to restrict the competition and hold back a landmark release. This does not seem to have been the case; Hollywood's studios were an incredibly close-knit community, and MGM felt its actions were for the greater good of the industry.

Orson Welles was very much an outcast in Hollywood. He was outspoken and displayed little respect for the self-appointed kingpins of the town, something which irritated them hugely. His contempt for his peers was underlined

by a willingness to discuss publicly the topic of money and its role as a driving force within the industry. In doing so, Welles was endangering the noble reputation of filmmakers along with their long-established and mutually beneficial affiliation with the media – after all, they were perilously reliant upon the likes of Hearst to promote their work. But Welles relished his outcast status and was famously quoted as saying: 'A good artist should be isolated. If he isn't isolated, something is wrong.'

He was no stranger to controversy, having faced a fearsome backlash following his 1938 radio broadcast, *The War of the Worlds*. Purporting to be a genuine news feature, the broadcast was aired in brief segments mimicking news

The New York Times.

NEW YORK, MONDAY, OCTOBER 31, 1938.

MEAD STANDS PAT AS A NEW DEALER IN BID FOR SENATE

Democratic Candidate Opposes Any Except Minor Changes in Labor and Security Laws

Radio Listeners in Panic, Taking War Drama as Fact

Many Flee Homes to Escape 'Gas Raid From Mars'—Phone Calls Swamp Police at Broadcast of Wells Fantasy

A wave of mass hysteria seized thousands of radio listeners throughout the nation between 8:15 and radio stations here and in other cities of the United States and Canada seeking advice on protective

OUSTED JEWS FIND REFUGE IN POLAND AFTER BORDER STAY

Exiles Go to Relatives' Homes or to Camps Maintained by Distribution Committee

bulletins detailing supposed reports of alien sightings. An adaptation of H.G. Wells' 1898 sci-fi novel of the same name, *The War of the Worlds* was waged live on air. While many listeners realised it was fictional, many more didn't, much to their embarrassment and indignation. Regardless of the uproar it caused, the broadcast was a huge critical success, revealing Welles' innate ability to use and alter the constraints of his medium. It enabled him to secure a highly beneficial contract with RKO Studios when they commissioned *Citizen Kane*.

When Louis B. Mayer, head of MGM, approached RKO offering $842,000 in exchange for the destruction of the reels of *Citizen Kane*, he was made aware of Welles' golden contract which made such a buyout impossible. But it mattered little. With Hearst controlling the advertising outlets and the rest of Hollywood set firmly against this bright young troublemaker, *Citizen Kane* faced a battle to even be seen. A number of the leading theatre chains, including Fox and Paramount, refused to show Welles' film as his

name was dragged through the Hollywood dirt. The film could so easily have died there and then. Under the threat of legal action a number of theatres relented but the film was a commercial flop, barely recouping the costs of filming. Rather predictably it was also overlooked by critics, only managing to scoop one of the nine Oscars for which it was nominated, and was greeted by vitriolic boos upon its announcement at the ceremony. Orson Welles was firmly cast as the enemy of cinema.

Welles struggled to recover from the slur campaign that ensued and, without the eventual recognition that *Citizen Kane* gained, he probably would not have had the chance to create another similarly innovative motion picture. Most influential works can be said to inspire a handful of subsequent films; *Citizen Kane* provided the blueprint for an entire genre. With the deep focus shooting style, Welles and Toland effectively expanded the canvas of directors, increasing the potential for storytelling and stylising. The depths of the screen that were once blurred out could now house a subtle subplot or simply reveal a character- deepening décor. This benefited almost every area of cinema, but none more so than film noir. This cinematic movement – French for 'black film' due to the extensive juxtaposing of light and dark – bridged genres and generations. It was a style that was most commonly used in ponderous, slow-burning dramas because of the subtlety it provided. Clues could be drip-fed to the audience in the dark corners of the shot.

The dark, moody shots filled with smoke and shadows which have become synonymous with 1950s America

would not have been possible without Citizen Kane. The techniques might still have come into use – indeed deep focus had been attempted before – but it was the complete package that made Welles and Toland's collaboration the springboard. Whereas Welles used deep focus to unsettle and intrigue the audience, it could just so easily have confused and distracted them. His low-angle shots could have come across on their own as unnecessary rather than stature-building, and the voiceovers which punctuated the film could have been clumsily deployed to deliver excessive exposition. It was Welles' masterful hand which tied all these elements together to showcase them as successful and worthwhile features. Had a lesser director unsuccessfully attempted to use them, Hollywood might well have steered clear of the habits and approaches that came to provide its distinctive image.

Even if another director had conceived of a film as innovative as *Citizen Kane* and had been able to incorporate the new methods of shooting it, it is highly unlikely that they would have been afforded sufficient creative control to do so. One of the key components in the success of Welles' production was the cast. Fresh from *The War of the Worlds*, Welles had a level of pulling power unmatched in the business, as was seen in his film-saving contract. So where most other directors would have been told to focus on their own department, when Welles demanded to be granted full control over all casting decisions RKO Studios were only too happy to oblige. Had they not, it is safe to assume they would not have made exactly the same choices as Welles. Realising the

need to find actors capable of filling the space opened up by deep focus, Welles called upon his own theatre company, the Mercury Theatre troupe. They had voiced *The War of the Worlds* radio production to great acclaim and went on to display an appreciation for set depth in *Citizen Kane* that would not have been guaranteed with most screen actors.

In a different world, one in which Orson Welles was spared the oppressive slur campaign, *Citizen Kane* might well have become one of the highest-grossing movies of all time. Its staying power suggests that it was not just the advanced cinematography that drew moviegoers in; but that is almost irrelevant. While audiences are the reason films are made, in this instance the only viewers of real importance were those in the industry, and once the film went to screen no filmmaker wanted to miss out on the controversial work. The critics might not have acknowledged its merits and his fellow filmmakers might have played down its innovative style, but it had been seen and undoubtedly left its mark. But if Louis B. Mayer's bid for the film's destruction had been successful, then the exemplar of American moviemaking that powered MGM and their contemporaries for decades to come would have disappeared without a trace.

Welles' outspoken nature meant that his opinions and frame of mind were always clear. His description of the politics involved in filmmaking requires little deciphering:

> A writer needs a pen, an artist needs a brush, but a filmmaker needs an army.

However, for all the opposition he faced, the success of *Citizen Kane* can be credited to Welles, Toland and a bulletproof contract. Welles had more fight in him than most armies and it's just as well that he did. Without his unwavering determination, the works of the last century would be a far shallower prospect, both in terms of subject matter and depiction. To remove *Citizen Kane* from cinematic history would be to deprive the medium of one of its true acts of genius.

Walt Disney and Dr Wernher von Braun

Imagine that...

Disney decides against collaborating with Hitler's former engineer ... and the USA never wins the 'Space Race'

The Disney empire is vast and illustrious. Boasting television channels, radio stations, theme parks and holiday resorts spanning the globe, in addition to its prolific catalogue of films and television programmes, The Walt Disney Company is one of the largest media corporations in the world and shows no sign of shrinking, having amassed upwards of $30 billion in revenue each year since 2004, even breaking the $40 billion mark in 2011.

So when it comes to identifying Walt Disney's greatest achievement, his most indelible impact upon the world, the competition is fierce. *Steamboat Willie* and in turn Mickey Mouse revolutionised cartoon television and cinema, Mickey going on to become the face of the Disney dynasty. In recent years *The Mickey Mouse Club* television show acted as a launch

pad for some of pop music and film's biggest stars in Justin Timberlake, Britney Spears, Christina Aguilera and Ryan Gosling. Despite such global impact, arguably Disney's most influential and noteworthy production is one that is almost unknown today. The work in question was not a blockbuster film. It was a four-part subseries of *Disneyland*, a weekly programme broadcast to the homes of millions in 1955; an imaginative project focused on space exploration and buried amid 1,220 editions of the programme. It went by the name of *Tomorrowland*.

At the helm were Disney animator Ward Kimball and scientist Dr Wernher von Braun. While Kimball's Disney footprint is much loved and widely recognised – responsible for the Pearly Band in *Mary Poppins*, *Pinocchio*'s Jiminy Cricket and the crows from *Dumbo* to name a few – Dr von Braun's legacy is less straightforward. It is one dogged by links to the Nazi party, no matter how unenthused and disaffected he was with their doctrine. The man who could have unwillingly, though not accidentally, powered the Nazis to victory became one of America's trailblazing pioneers. It was Adolf Hitler who had first recognised his talents in aeronautical engineering, propelling him to the forefront of the nation's aviation efforts.

Wernher von Braun had little interest in the Nazi war effort. In September 1944 a V-2 rocket, his first device to be launched in battle, crashed down in the city of London. Hitler and his military men considered the launch to be an overwhelming success but, when asked his thoughts on the air strike, Dr von Braun's words revealed that his motives

Dr Wernher von Braun

differed from theirs. 'The rocket worked perfectly except for landing on the wrong planet,' he said. It was a bold statement and wildly ill-considered from a personal freedom stand-point. von Braun had grown increasingly frustrated that his efforts were being focused on earthbound projects and made his feelings known in the following weeks and months, before the SS finally took action. His disgruntled outspokenness was regarded as unpatriotic and Hitler called for his arrest.

His detainment lasted only two weeks, however, before he was released and reinstated in his position as the head of the rocket programme. Despite their differing agendas, von Braun had become an indispensable member of Hitler's staff. With the war swaying ever in favour of the Allies, the Nazis had pinned many of their hopes on the V-2 rocket programme and so von Braun's detainment stalled the Nazi effort considerably.

As the end of the war drew into sight the US and the Soviet Union set about obtaining the Nazis' technological intelligence, such was its financial value. The US named their quest Operation Paperclip and placed von Braun and his work in aviation at the top of their list. It had become abundantly clear to von Braun that he, too, needed to plan for the post-war era. As Allied troops advanced upon deepest Bavaria they were greeted by a surrendering Wernher von Braun, along with his entire engineering team. A brief but thorough period of interrogation followed before von Braun was liberated, both from incarceration and from earthbound aviation. Working in the US, he would finally get his chance to tackle the final frontier.

Weighs 10,000 #
Weighs 50,000 # (full)
Total 60,000 #

if a 2-stage Sat V
lug 220,000 # payload
...ing above S-II) into a
orbit; and if all "shells" incl. I.U.
another 20,000 #,
"Space station equipment"
... may still weigh

220,000
80,000
40,000 # (incl. RCS)

Apollo (or
Gemini)
docking cone.

...ntrol
...ormal

Room for
antennas, windows,
additional docking cones etc.
To get from
Apollo or Gemini into
space station, astronauts
pass through this 10 ft tunnel.

Space station
...uipment module" in
final position
...odates environm.
...t equipment,
...nications equipm,
...ch gear,
...supply,
...d water
..., sanit.
...ies, cooking
...d food storage

Service
Module

Adapter

I.U.

S IV B
"shell"

or
separation
here

10 ft

33 ft

Oxygen tank
may be used

Common
bulkhead

Sat. V conve...
into a S-I...
space statio...
by means o...
a cylindrica...
movable
"equipment
module...

11/29/...

Space station
equipment module
in boost flight po...
(Note ideal serviceab...
during prelaunch prepa...

S IV B "shell," I.U. and ad...
are removed for activat...
of S II -stage as
orbital station.

After injection into or...
and subsequent complete...
of S II hydrogen tank, ...
module is moved (hydra...
into hydrogen tank, convert...
latter into space st...

Expandable platforms
from central ...

Insulated walls

🚶 - 6 ft man

S II sta...

S-II surface, cover...
with solar cells, c...
easily provide 5 k...
even if station is n...
attitude - stabilize...

And so began a mammoth exercise in both engineering and PR. The first task for von Braun was to devise an operable method of transporting man into space. He had long considered just how he might go about doing so, but with strong backing he was finally in a position to realise his vision. Post-war, the USA had become embroiled in the Cold War with the Soviet Union, a bitter tangle for supremacy which only heightened the significance of the what came to be known as 'the space race'. The prestige and momentum that would accompany the feat of being the first nation to put a man on the Moon would deal a hammer blow to the morale of the opposition. As a former member of the Nazi regime, von Braun represented an unlikely leader for the USA's efforts and as such faced a big challenge in trying to win over the public. The enigmatic nature of his work proved an advantage, as numerous media outlets clamoured for a sneak peak at his blueprints. In 1950, he was approached by American investigative magazine *Collier's* to reveal his vision to the nation. He duly agreed, outlining his bold plans complete with illustrations. It was only a glimpse but it mobilised imaginations. Not least Ward Kimball's.

As far as collaborations go, the meeting of minds between Kimball and von Braun could be regarded as either one of the most unlikely or most sensible, depending on how you look at it. From one perspective, it was a highly ranked aviation engineer working with a man who had made his name drawing cartoon crows and crickets – bizarre. Yet as von Braun's project was beyond the comprehension of many people, to enlist the services of such a talented animator to

convey it made perfect sense. Either way, their work together took on an unusual tone. With Disney's most famous fairy, Tinker Bell, fronting the opening credits, one could be forgiven for thinking that *Tomorrowland* was the stuff of childish fantasy.

The series was narrated by famed voice actor Dick Tufield, who later voiced the Robot in the iconic TV series *Lost in Space*, as well as by Kimball, von Braun and a number of notable scientists. The strong mixture of personalities from academic and entertainment backgrounds was evident in the programme's light-hearted approach to the subject of space exploration built upon a strong scientific foundation. These four space-focused episodes of *Disneyland* were a big hit with family audiences and were later reproduced in various forms; the first and most prominent, 'Man in Space', even being transformed into a classroom textbook. To those watching, it was a successful and inventive burst of entertainment, but behind the scenes the master plan extended far beyond simply notching up viewing figures.

With numerous goals and landmarks to achieve, the space race can be broken down into many stages. Being the first to exit Earth's orbit, to land an unmanned craft on the surface of another planet and to successfully navigate a manned craft in orbit ranked among some of the rival nations' most prized targets. However, there was one 'first' that the two

nations coveted most of all – to put a man on the Moon. For a long time it looked like the Soviets were going to claim all of these records, as they engineered both the first manned and unmanned space orbits. In fact, they had sent the first-ever artificial satellite, the now-famed Sputnik 1, into a low Earth orbit before America's NASA (National Aeronautics and Space Administration) had even come into being.

In 1958, three years after the futuristic *Tomorrowland* episodes were first aired, Wernher von Braun was asked to play a central role in the creation and running of America's space programme, NASA. This made America's acquisition of his services post-war all the more significant; he had leap-frogged a host of home-grown engineers. In 1961 the Soviet Union's equivalent to NASA, the Vostok programme, won the race to send the first man into outer space, with cosmonaut Yuri Gagarin aboard. Gagarin completed his orbit of Earth in 108 minutes, a vital statistic as endurance would prove to be the next challenge for both nations to overcome. If they were to make it to the Moon and back they would need to travel over 470,000 miles – the circumference of the globe is approximately 25,000 miles. Naturally, Gagarin's orbit signalled to the world that the Vostok programme was a step closer to putting a man on the Moon than its American rivals.

In fact it would be a long time until either programme succeeded, with just over eight years passing before America's *Apollo 11* shuttle touched down upon the surface of the Moon on 16 July 1969. The success of the shuttle, manned by Neil Armstrong, Edwin 'Buzz' Aldrin and Michael Col-

lins, rightfully bestowed great acclaim upon the intrepid explorers, but credit had to go to hundreds of people behind the scenes. And Kimball and von Braun were among these people. Far from simply providing space-themed entertainment, their work on *Tomorrowland* under the Disney name was arguably make or break for the US space programme. As we shall see, a poor response to the show held the potential to derail or even end America's efforts.

Disney's 'Man in Space' stood out in an era obsessed with space travel. While there was no shortage of discussion on the topic, very few media outlets even attempted to tackle it in such detail or with such an informed, educational grounding. This was all the more remarkable when one con-

siders the surrounding circumstances. In a 1969 interview Kimball admitted that when the idea was first pitched it was little more than a token representation of futurism.

> Walt was opening up Tomorrowland, he had to have something. I was always a UFO fan anyway, so when I went to Walt with the Collier's [article on space exploration] and he said, 'Hey, this is the way we should go,' it was sort of mutual agreement.

By 'Tomorrowland' Kimball was not referring to the series alone. It was also a section of the Disney theme parks, a bold extension of the entertainment empire. As other media institutions were wary about the subject of space travel put off by its complex and seemingly far-off nature, Disney's embracing of the idea was initially powered more by commercial necessity than any sense of educational duty. The eventual form of the *Tomorrowland* series was the result of fortunate coincidences and serendipity, even with the great detail and research that went into making it.

In later years Ward Kimball told of how the programme came to be valued by the government and left those listening in little doubt as to the magnitude of Walt Disney's ambition. He revealed in a speech shortly after 'Man in Space' had aired that he, von Braun and Walt Disney had been in talks with the United States Air Force (USAF), the organisation responsible for space research before the birth of NASA, about making another space-centric production, this time centred on the phenomenon of UFOs. Few would

have suspected that Disney could offer the government any-thing in terms of a propaganda outlet but, having produced masses of film for troops during the Second World War, the two parties had forged a strong relationship by the time the space race was in full flow.

The requirement outlined by USAF was simple – remove the fear factor attached to space travel. A certain brashness had swept through those in power after the war; a combina-tion of the sense of invincibility having defeated the Nazis, the need to beat the Soviets to the Moon and the feeling that space was, as it was so commonly called, the final fron-tier. Yet amid such determined focus, doubts still festered throughout America as to just how wise a target space travel was. With the public knowing so little of the universe beyond our planet, the US government realised that they were unlikely to gain the nation's backing until such fears had been allayed. It just so happened that in Ward Kimball, USAF had found the ideal man to sell their intentions to the masses. Although von Braun was the one who had been hired to provide specialist knowledge, Kimball had har-boured a keen interest in UFOs and space travel long before the American authorities came calling.

The finished product provided President 'Ike' Eisenhower with a perfectly concise tool with which he could diffuse fear and criticism in equal measure. It was the first time space exploration had been presented as reasonable and approachable, and explained in a manner that even chil-dren could understand. The proposed UFO production would have differed greatly from this successful model. In

any case it was never completed; presumably because 'Man in Space' was sufficient for Eisenhower's needs, although no official explanation was ever given. Whereas 'Man in Space' essentially consisted of von Braun's expertise in engineering and well-reasoned scientific theories framed by a brightly coloured studio and likeable voice actors, the UFO special would have been based much more on bright lights and animation than fact, containing little more than positive thinking and hopeful guesswork. Disney's animators were instructed to conjure up their best impressions of what an alien might look like, and were promised top-secret reels of the government's UFO surveillance footage to accompany it.

The footage never arrived, which is probably for the best. Crossing the line from entertainment to pure propaganda is potentially irreversible. During the war, Disney had portrayed their much-loved cartoon characters in situations of conflict, even making direct references to Nazism in *Der Fuehrer's Face* (1942), but this was as close to risk-free as propaganda could get. As space travel was such a hotly debated topic, with no clear consensus on the matter, for Disney to stand firmly on the side of space travel would inevitably have painted it as an agenda-driven institution.

With the programme investigating and examining UFOs remaining a mere pipe dream, the USA took momentous strides and eventually made aeronautical history with the Apollo programme. Kimball revealed that President Eisenhower had remarked, upon requesting a copy of 'Man in Space': 'I'm going to show it to all those stove-shirt generals who don't believe we're going to be up there!' Such aggres-

sive intentions would doubtless have rendered the UFO edition a dogmatic failure.

Of course, the American government's intention to reach the Moon was powered by the competition of the Soviets rather than the work of Walt Disney and his team. The desire would have remained, but America would have lost one vital asset – Dr Wernher von Braun. The exposure afforded to von Braun's vision in 'Man in Space' helped to secure his role at the head of NASA's operations. The association with Disney tempered his links to the Nazis, making him a more useful asset for USAF and eventually NASA. Otherwise, the US government's decision to incorporate an unknown former Nazi engineer into its most vital military works could so easily have sparked fear and outrage.

Although Disney's long-standing association with the American elites suggests that a series like *Tomorrowland* would eventually have been commissioned had it not already been in production, it would have lost its air of innocent wonder. The former Nazi engineer would not have been appointed and, without his vision at the heart of the production, the plausibility and integrity of the programme would have suffered. The absence of a political agenda coupled with the wide-eyed enthusiasm of Kimball and von Braun combined to create an influential and convincing programme. It went beyond its original intentions and without *Tomorrowland,* or on the other hand *with* an unnecessary UFO follow-up, the USA's attempts to set foot on the Moon could so easily have been hampered by division and dissent, leaving the Soviets to plant the first flag on its surface.

Imagine that ...

George Lucas fails to find a backer for *Star Wars* ... and cinematic technology loses its greatest pioneer

Good luck has its storms.
George Lucas

In 1971 George Lucas began work on his first major block-buster, *American Graffiti*. A coming-of-age tale of small-town teenagers, the film was the first motion picture to be produced by Lucas' own company Lucasfilm. He faced widespread studio scepticism, receiving rejections from numerous distributors including Metro Goldwyn Mayer, Paramount Pictures and 20th Century Fox among others as he set about financing his film. Eventually, he was made an offer by Universal Studios – they would provide a small budget for the film but Lucas would retain full creative control. Lucas gratefully accepted and the deal proved to be

George Lucas

a lucrative one. *American Graffiti* drew great critical acclaim and was loved by much of its audience; Lucas created a compelling snapshot of 1960s teenage life in front of a stylised and nostalgic backdrop. Overwhelming and unexpected box office success saw Lucas become a multimillionaire almost overnight.

Not only had *American Graffiti* made Lucas millions, it had also made his name in Hollywood. He suddenly found himself one of the hottest properties in cinema, but even with such a reputation he faced an uphill struggle to convince distributors of the viability of his next project. Their concerns were understandable, as his follow-up was a far more ambitious and complex idea than *American Graffiti* and very different in terms of subject matter. There was no guaranteeing that Lucas was capable of pulling it off. When he presented Universal with a synopsis for a space-based epic titled *The Journal of the Whills* they politely declined, failing to be won over by the embryonic plotline and deterred further by the eye-watering budget. It was a rough diamond at best.

Thankfully for Lucas, his previous work had secured some powerful admirers including Alan Ladd Jr., the head of creative affairs at 20th Century Fox, who would later become the studio's president. Ladd's willingness to back Lucas was more out of admiration of his earlier works than any strong convictions about his latest offering. It later emerged that Ladd had set his sights on working with Lucas before *American Graffiti* had even made it into cinemas, having been completely mesmerised by a pre-release reel of the film.

With backing finally in place for his grand project, Lucas

went away and attempted to hone the idea into a more accessible storyline as studio bosses had struggled to make sense of his initial pitch. A complex tussle of compromise and principles followed. The more he tried to outline his vision, the grander the project became. The name was changed to *The Star Wars*, before the prefixed '*The*' was eventually abandoned. The rough initial outlines of his characters were gradually and comprehensively coloured in, but it would take a number of drafts before Lucas managed to weave them into the complex web that formed the foundation of the final storyline. When the film finally hit cinemas in 1977 it had cost Fox $11 million.

Alan Ladd Jr. and 20th Century Fox were understandably shocked when fewer than 40 cinemas ordered copies of the film ahead of its opening weekend. With so much invested in *Star Wars*, the studio entered into aggressive bargaining with cinemas and theatre chains across America. They threatened to withhold copies of later hit releases if more theatres did not order copies of *Star Wars*. They did not have to fight for long, however, as the viewing figures soon spoke louder than any threats could. Even with only 32 cinemas showing the film on the opening day, *Star Wars* made over $250,000. As word spread, the clamour for Lucas' latest production increased further still with another $1.25 million being taken in US cinemas in the opening weekend alone. Over the course of its record-breaking 44-week stint in the US it brought in $460,998,007 and made a total of $797,900,000 (roughly £495 million). These figures are even more impressive when you consider that in 1977 the

average ticket price for a film in the USA was little over $2.

Lucas had only scratched the surface of the *Star Wars* story and so, with colossal demand for a follow-up, production of further episodes in the series was soon under way. In later years Lucas said: 'It wasn't long after I began writing *Star Wars* that I realized the story was more than a single film could hold.' By 2008 the saga had stretched over seven films in total and a fair amount of reordering had taken place. In the overall chronology of the tale, the original 1977 picture is now considered the fourth film in the story, with three later-released prequels. 2012 saw a landmark deal in the history of the franchise as Lucas agreed to sell his personal venture Lucasfilm and all associated *Star Wars* rights to Disney for £2.52 billion. It remains to be seen whether the changeover will reignite the series, since Lucasfilm's more recent *Star Wars* offerings have been heavily criticised. Fans lamented the clunky integration of characters and settings that had been created using computer-generated imagery (CGI), as the production company struggled to adapt an old series to fit a new era of cinema. This issue is something that Disney will need to overcome if they are to rejuvenate the series.

Nevertheless, the legacy of *Star Wars* and Lucasfilm is undoubtedly one of great success. When George Lucas was scraping around for funding for his initial films the movie business was a vastly different place. Science fiction had rarely looked so vivid, and even when it did the storylines had never been rich enough to sustain a series as large and absorbing as *Star Wars*. Lucas' complex world raised the bar for science

fiction and cinema as a whole. It can even be argued that the very fact that Lucas' creation finally started to tire after more than two decades is due to the lessons that rival producers learned from *Star Wars*. With the innovations of *Star Wars* becoming the industry standard, the novelty of the series' spacecraft and gadgets was lessened by the improvement in the competition, as the chasing pack finally caught up. Lucas' tenacity and spirit when searching for backers paid off handsomely, as he now boasts a personal wealth reaching into the billions, but had his search proved fruitless then it is not just his bank balance that would be different today.

The strength of the *Star Wars* legacy lies in the wide-reaching and deep-rooted manner in which the franchise has penetrated popular culture. Few films or film series have ever managed to have as powerful an impact upon cinema, and arguably none has ever influenced the 'real world' as visibly as *Star Wars*. It is difficult to track the true influence of any entertainment phenomenon due to the distorting effect of fanatical support, but there are abundant examples of Lucas' impact demonstrating that the world would be vastly different without his catalogue of works.

At the most basic level, without the success of *Star Wars* George Lucas would have struggled to forge a career anywhere near as successful as the one he has enjoyed. The struggle he endured in convincing 20th Century Fox to

back his idea reflected the financial gamble it represented. In order to capitalise on the success of *American Graffiti* it was imperative for Lucas that *Star Wars* was made when and with the budget it was. Time would only have acted to blur his reputation. Whereas it is easy to be wowed by futuristic computer-generated imagery against the backdrop of the iconic *Star Wars* Death Star, the carefully crafted vignettes of *American Graffiti* blurred seamlessly into their 1960s setting – the subtle hallmark of a masterful filmmaker. It was essential that Lucas made his transition into big-budget blockbusters while his breakthrough picture was still fresh in the collective memory.

After the success of *American Graffiti*, Lucas would almost certainly have produced further films, even without *Star Wars* under his belt, but in time film studios would have seen far less reason to back Lucas with the large budgets science fiction requires. After all, his grounding was in 60s teen dramas. The result would have been more character-driven films, as his favoured grandiose sci-fi movies would have become unachievable. This change of path would have endangered the legacy of another of cinema's most popular franchises – *Indiana Jones*. Lucas co-wrote and executive-produced the *Indiana Jones* films with fellow superstar director Steven Spielberg. The two have long run side-by-side in the world of movies, competing and collaborating to raise the bar, a mutual admiration that was set in motion when Spielberg first saw *American Graffiti*. Speaking about his friend, Spielberg once said: 'I was most jealous of George because I thought and still do to this day, I just

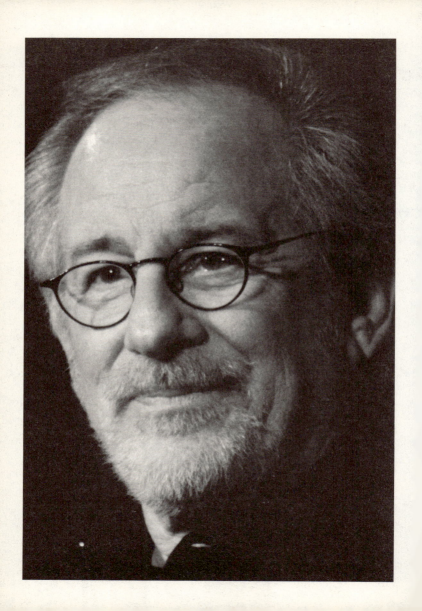

thought American Graffiti was the best American film I'd seen.' Whether or not Spielberg (pictured left) would have chosen to collaborate with Lucas without the proven success of a big-budget franchise is unclear. Either way, the footprint of *Indiana Jones* pales in comparison to that of *Star Wars* and would not on its own have given Lucas the level of influence he holds today.

Far from being just an ambitious storyteller, on the back of his *Star Wars* successes Lucas pioneered a number of technological advances in the world of filmmaking. When in 2012 The Walt Disney Company bought out George Lucas' Lucasfilm there were mumbles from many critics that, after decades at the forefront of the industry, Lucas had fallen out of touch with modern cinema. Yet they failed to mention the

indirect role Lucas had played in keeping Disney relevant since the mid-80s. As the *Star Wars* series began to flounder, Disney went from strength to strength with animated hits such as the *Toy Story* trilogy (1995–2010), *A Bug's Life* (1998) and *Finding Nemo* (2003). Departing from the wholesome hand-drawn cartoons that had come to symbolise Disney, the 90s saw the film company turn to glossier computer-generated pictures, much to the delight of audiences. All very well, but what's this got to do with Lucas?

In 1986, George Lucas sold a subsidiary department of Lucasfilm to technology giant Apple's boss, Steve Jobs. Originally known as The Graphics Group, it was the arm of Lucasfilm that focused on researching, experimenting with and eventually providing computer-generated graphics. With Steve Jobs a strong candidate for the most iconic figure technology has ever known, it is easy to understand the appeal The Graphics Group held for him. Under his and Apple's control it became Pixar, today standing as the ani-

mation sector's most prolific institution. Most significantly, Pixar provided the technological expertise for Disney's foray into CGI, producing the aforementioned hits (*Toy Story* et al) that were distributed with Disney's marketing know-how. As of 2012, Pixar have yet to produce a film that has not cracked the all-time top 50 grossing animated movies. Without *Star Wars* Lucasfilm would have remained a self-funded operation out of necessity and, as such, Pixar would not have come into existence.

Naturally, the Lucas empire was not contented with its exploits in the world of CGI, boasting numerous other subsidiaries including ones specialising in marketing, videogames and even education. The third most successful wing of the business, behind the filmmaking and The Graphics Group, was the sound engineering department. Continuing Lucas' steady and unrelenting domination of the entertainment sector, in 1980 Lucasfilm took the sound production for the third *Star Wars* film, *Return of the Jedi*, in-house. He recruited audio scientist Tomlinson Holman to devise a new audio system to improve the experience of moviegoers. Holman realised that no matter how much clarity he could achieve in the film's sound quality, it would not transfer to the substandard equipment of the cinemas in which it would be screened. Resetting his sights, Holman engineered an audio system that would revolutionise modern cinemas, providing a system of sound production that would reproduce film soundtracks to the standard intended by the film companies. It was named THX, standing for Tomlinson Holman Crossover, and first hit cinemas in 1983, coinciding with the

release of *Return of the Jedi*. By 2002 there were 2,700 THX-certified cinemas worldwide, a number which has remained largely the same to this day despite the ever-present offerings of competitors.

While all of this industry success is impressive, it is Lucas' impact on seemingly unrelated domains that would have suffered the most had the *Star Wars* series never come to fruition. The meticulous marketing of each film was overseen by Lucasfilm and ensured that, as the company grew, their work targeted their intended demographic with unerring accuracy. Lucas Marketing deployed merchandise and advertising campaigns in tandem to get their films into theatres. But this is where their control ends. Like any other director, once Lucas' films hit the big screen they are turned over to the public to be appreciated, analysed and critiqued. Few directors see their films go on to be played out in the real world with elements being lovingly replicated in the name of science or even conflict; but Lucas has.

Technology fanatics were left open-mouthed when, in September 2012, American engineering company Boston Dynamics revealed its latest robotic creation. This is because the Legged Squad Support System (LS3) bore an uncanny resemblance to a pre-existing machine, or at least a pre-conceived one. The *Star Wars* films feature some stunning landscapes on fictional planets and as a result Lucas created specific 'vehicles' to carry his characters across such unforgiving terrain. He named these 'walkers'. So when Boston Dynamics revealed the LS3, a device designed to aid troops and marines in transporting equipment and traversing dan-

gerous zones, it was instantly apparent that the creators had taken inspiration from Lucas' walkers. In fact, the similarities between the LS3 and one walker in particular – the All Terrain Tactical Enforcer (AT-TE) – were so striking that it could seemingly have been designed by Lucas himself. With a large core or body containing the power source along with other essential elements, the LS3 is supported and propelled by four legs, much like a mammal. Some of Lucas' walkers had four legs, although the AT-TE had six. Beyond the leg shortage, the two mechanisms looked superficially the same. This wasn't simply a homage to the film series, but rather Boston Dynamics uncovering a feasible solution to the difficulties of rough terrain travel.

The LS3 provides perhaps the most striking example of _Star Wars_ inventions coming to life, but by no means the only one. The fetishistic depiction of technology in the films has long since inspired young scientists and inventors. The lightsaber has become one of the most iconic science fiction creations in history; the aircraft hang in replica form from the ceilings of children's bedrooms across the globe; Californian engineers Aerofex have even created a hover bike in the image of another of Lucas' inventions, Land Speeders. The degree to which _Star Wars_ has penetrated modern culture is unrivalled. With such a broad reach, Lucas' works (both artistic and technological) have made cinema more visceral and realistic than ever before. Without his greatest production, an ever-growing share of films from the late 20th century onwards would have been far less striking productions. The sound would have been less crisp, the computer imagery less clear. One thing is for certain: if Alan Ladd Jr. had not taken such a brave punt on a young George Lucas, then modern cinema would have decades of catching up to do.

Imagine that ...

Charlie Chaplin sticks to stage entertainment ... and cinema stumbles on blindly without its most famous son

Having spent a childhood performing in the music halls of south London, Charles Spencer Chaplin's first love was the stage – the music hall stage to be precise. In 1910 he was recruited by Fred Karno (right) to join his touring stage company and proved to be an instant hit. Word spread of the prodigious new talent, as far afield as the west coast of America. Despite such acclaim, Chaplin remained focused on self-improvement. When California's Keystone Film Company sent a telegram requesting the Brit's services, he accepted, but somewhat

reluctantly. Chaplin admitted in his autobiography that he saw it as little more than a profile-building exercise: 'I was not terribly enthusiastic about the Keystone type of comedy, but I realized their publicity value.' The salary offered by Keystone was also believed to be more than double what Karno was paying him.

Chaplin struggled to settle in his new surroundings. He was starved of the instant adulation and celebrity status he had enjoyed back home, and cinema was a far cry from the music hall stage. He bemoaned the lack of scripting and rehearsal, as well as the unrelenting pace at which the Keystone comedies were produced – the majority of them were fast-paced 'chase' films. It is rumoured that his repeated complaints caused the producers to strongly consider parting company with their newest recruit. But they persevered, and in his first year Chaplin starred in a colossal 35 movies, evidence of the hasty production he had derided.

While fans and critics alike would argue that Chaplin's work at Keystone does not rank among his best, one film in particular was revolutionary: *Kid Auto Races at Venice*. This film gave birth to The Tramp; a homeless wanderer dressed in top hat and tails, down on his luck yet hopelessly optimistic. Audiences loved the character and he became a regular fixture in Chaplin's films. However, the success of the films did not go hand in hand with a stronger relationship. Chaplin had outgrown Keystone and they both knew it. Despite having been granted greater input into all areas of the production process, directing and even retaining the rights to many of his films, he still had his sights set on bigger things.

Witzel
LA.

As Chaplin's celebrity and critical acclaim grew, so too did his business acumen. With offers coming in from rival production companies, he was able to put this skill into practice. The popularity of his films, particularly *The Tramp*, gave him bargaining power and transformed him into a commodity, with many loyal customers already in place. This attitude was not driven by an agent, or an adversary. Chaplin was financially aware in a way that no other film star had ever been. A year working for Essanay Studios followed. Lured not least by the generous salary, Chaplin was also given the artistic control he so desired, including his own production unit. It was the perfect platform. His education at Keystone was undeniably evident in his new films, the comedy chases and farces were still very much present; but now they were balanced out. Chaplin built the characters, slowed the pace and rounded the storyline. The fifteen films he made with Essanay

gained major critical acclaim and were even praised by stars of the stage – something that was unheard of at the time.

Already very popular and displaying a Midas touch, Chaplin was ready to experiment. Mutual Film Corporation offered him over half a million dollars to produce twelve two-reel films, an offer he duly accepted. The deal topped up his already considerable wealth, but was anything but a mercenary move; in these comedies Chaplin delved into darker, politically charged subjects, pushing artistic boundaries. The most notable of the twelve saw a reappearance of the popular Tramp in *The Immigrant* (1917). The film criticised the treatment of immigrants by US officials, with The Tramp fighting for their cause. The character that had first appeared in his fast-paced, light-hearted Keystone comedies was now at the heart of a daring satire, in one scene kicking an immigration officer's rear. Chaplin's considerable and rapid progress was clear for all to see.

By 1919 Chaplin no longer needed the assistance of film corporations. He had recently become the first ever millionaire film star, in no small part thanks to his shrewd negotiation

of contracts and rights. He used his reserves to set up United
Artists, accompanied by fellow film personalities Douglas
Fairbanks, Mary Pickford and D.W. Griffiths. It proved to
be a huge success. The quartet were tiring of the growing
restrictions imposed by film corporations, and this way they
were able to assume total control over every aspect of their
work. In time, Chaplin took to composing scores to accom-
pany his films, typically opting to keep dialogue minimal.

The resulting films cemented Chaplin's place among
cinema's greats. The artistic freedom he had gained from
his new venture paid off; Chaplin expressed great pride at

the quality of their productions, claiming that *The Gold Rush* (1925) was the film he most wanted to be remembered for. This wish would not be granted, as it was displaced by the 1940 release of *The Great Dictator*. In this picture Chaplin mimicked and goaded Hitler. His comic portrayal of the Nazi Party stirred public feeling at a sensitive time, especially since the USA had yet to enter the war. When word got out that such a film was in production, a number of authorities imposed bans; however, these bans were soon lifted when the film received unwavering support from audiences. It

United Artists Corporation

Company.

ORGANIZED
UNDER THE LAWS OF

Delaware

Alphabetical List of Stockholders,

AT CLOSING OF BOOKS ON THE 16th DAY OF March 1920

NAME	RESIDENCE	SHARES	
		COMMON	PREFERRED
Charles Chaplin	Los Angeles Calif	1000	300
Douglas Fairbanks	Los Angeles Calif	1000	300
David W. Griffith	720 Longacre Building New York NY.	1000	300
Gladys Mary Moore	Los Angeles Calif	1000	300
William G McAdoo	120 Broadway New York NY.	1000	
		5000	1200

Cantled

Secretary

was an act of supreme bravery, and Nazi archives reveal that Hitler had marked Chaplin down as an enemy because of it.

Had Chaplin stuck to his original plan – to return to music hall after raising his profile via the big screen – the Western entertainment world would look very different today. He was not alone in his love of music hall or its US equivalent, vaudeville. The American public's love of the theatrical variety shows had grown and grown since the 1880s. The influences were as varied as the performers. The vaude-

ville productions of different theatres reflected the cities they were based in. Yiddish vaudeville was considered by many to be the most provocative brand, with edgy comedy and musical productions that lit up the New York scene. Exported influences from Chaplin's favoured English music halls formed a large part of many productions. The stage was already set for his irresistible brand of slapstick comedy to dominate the American vaudeville scene, but instead he helped to destroy it.

The diverse make-up of vaudeville was vital to Chaplin's success. As filmmakers were still getting to grips with the increased capabilities offered by cinematic technology, it was important to ensure that the building blocks of entertainment as they knew it remained. As a result, it made

taking a punt on Chaplin's talents less of a risk for the likes of Keystone. Music hall had already provided a gruelling testing ground for his English slapstick. It was not just Chaplin who successfully made the transition from stage to the big screen; none other than American movie star James Cagney made the move from vaudeville, among others.

It was not just the loss of Chaplin, Cagney and

company that sounded the death knell for stage entertainment. Big-screen productions ran alongside vaudeville for a number of years as the two battled it out for audience share and, with television still decades away, the social element of theatre still underpinned the arts. Silent film had far more in common with vaudeville than cinema's later incarnation, the 'talkie', did. Without the outlet of vocal expression, silent films relied on the same bold, expressive body language that had been honed for years in music halls and vaudeville shows. As a result, slapstick also remained a key feature, with physical comedy playing to the strengths of what was still a predominantly visual medium.

However, for all the seemingly vaudevillian light-hearted entertainment on show, cinema did represent a step forward in more than just the medium of production. Departing from the heavy focus on variety, silent movies were more measured. Chaplin excelled in breaking down slapstick into a slower, more considered form. While the character of The Tramp had its origins in its creator's experience of stage entertainment, it was made for cinema. The subtleties of Chaplin's most iconic creation benefited from the drawn-out storytelling of a longer set – one that simply would not have been afforded to even the most successful of stage acts. He was able to toy with the audience's preconceptions of the homeless individual, raising and lowering expectations and aspirations as the story progressed. The depth of character challenged audiences, knitting comedy and drama together and leaving them to decide where the line was.

Chaplin's ventures into film revolutionised the medium,

but they shaped him in equal measure. Explaining his habit of merging thematic devices, Chaplin once said: 'Life is a tragedy when seen in close-up, but a comedy in long-shot.' His choice of words is revealing; it shows that he appreciated the role of emotional distance in comedy. Few images are so synonymous with silent movies as that of a damsel in distress shown at a distance, tied helplessly to the train tracks as a steam locomotive appears on the horizon, hurtling towards her. Chaplin's use of cinematic terminology suggests he had found more in the world of film than he had first expected. This was all but confirmed by his transition from film star into producer and director. Had he opted to return stubbornly to the stage it would have been in spite of his best interests.

It would be remiss to suggest that Chaplin had invented pathos or the combination of comedy and tragedy. These juxtaposed themes had long been part of stage entertainment and literature when the reluctant film star turned up at Keystone. William Shakespeare was renowned for it, as was Geoffrey Chaucer. It has been a staple of comedy and drama, at least the British varieties, for centuries. As such, having grown up in English schools and with English entertainment, Chaplin's toolbox in the early days of cinema differed greatly to those of his peers. As directorial pioneers and actors tiptoed half-blind into the new medium, they had no option but to learn from one another's mistakes. Had Chaplin not been around to so successfully present his brand of British comedy then cinema might have stumbled on, devoid of its sentimentally farcical foundation, for

decades. Acts like Benny Hill might never have gained their vital inspirations, a particularly poignant thought as Hill later discovered that he had come to be idolised by Chaplin in return.

Artistic merit aside, the potential for celebrity profile was nowhere near as big in music hall or vaudeville as it was in cinema. Chaplin's choice, simply put, was the opportunity to continue in the stage tradition versus paving the way for a new brand. There was arguably less risk in music hall as he had already risen close to the top when he left, but there was a definite ceiling. The commercial viability of vaudeville paled in comparison to that of its new challenger. The ability to distribute canisters of film instead of troupes of actors immediately widened the potential audience. Provincial towns no longer needed to miss out on the star acts.

Not only was film more readily portable, the industry had no stars, no precedents and most vitally no structure. It would have been unheard of in stage productions for such a young actor to step up to the role of director, or to gain artistic control. With no long-established stars to overtake, Chaplin had a clear shot at superstardom. He could rise to the top with relative ease. Even the biggest stars of vaudeville had to contend with the reputations of the stars of yesteryear, their reputations heightened by nostalgia much as the movie stars of Chaplin's era are today. Had he stuck around to fight it out among the hierarchy of a dying form of entertainment then most of us would probably never have heard of Charlie Chaplin.

Of all the appraisals he received during and after his life,

perhaps the most telling came in the inaugural Oscars in May 1929. Upon realising that Chaplin was going to walk away with awards in every category, the organisers withdrew him from the running, instead gifting him an honorary award: 'For versatility and genius in acting, writing, directing and producing *The Circus*.' This was not just evidence of an artist excelling in his field, it was recognition of the fact that Chaplin had come to completely transcend it. It happens from time to time, an era of prowess that completely revolutionises a sector. Boxing has had Muhammad Ali, literature had William Shakespeare and in the early 1900s cinema found Charlie Chaplin. That's the key – cinema found *him.* If the Keystone Film Company had not come calling then it is unlikely that Chaplin would ever have absconded from his beloved music hall in search of a film career. Since that time cinema has had a huge impact on the rest of the entertainment and cultural world, but it was Chaplin's influence that made it all possible.

Imagine that ...

Casablanca's writing commit-
tee takes total control ... and
the film's greatest moments are
whitewashed from history

It is often asked of movie stars and directors whether they realise that a line is going to become iconic when filming. The answer, more often than not, is 'No'. This is partly down to the fact that so many factors can contribute to making a good line great. Some remain fixed in the ears of the audience due to their lyrical composition, such as Clark Gable's historic 'Frankly, my dear, I don't give a damn' in *Gone with the Wind* (1939). Others gain fame due to the unforgettable characters who deliver them; 'The name's Bond, James Bond' for example, or Robert De Niro's famous 'You talkin' to me?' mirror soliloquy as Travis Bickle in *Taxi Driver* (1976).

However, once in a while, a film will come along where line after line goes down in history. There are few better examples of such a film than the 1942 wartime classic *Casa-*

blanca. The film starred two of the biggest names in cinema at the time, Humphrey Bogart and Ingrid Bergman, and the plot was undeniably ambitious. Predictably set in Casablanca, an unoccupied part of North Africa during the war, the film detailed the restraints put on love and relationships during a time of great conflict and as such – despite being set in a supposedly exotic land – audiences across the globe could relate to it. With such solid building blocks the film always stood a strong chance of standing the test of time, which it undoubtedly has.

Yet for all of the film's emotive and political content, the lines that have resonated the most in the years since do not focus on war or unrest. They are not wise mottos for war-torn lovers to cling to, nor are they scathing attacks on man's inhumanity to man. Quite the opposite, at least at first glance. The film contains at least three of the most oft-repeated lines in the history of film:

'Of all the gin joints in all the towns in all the world, she walks into mine' – Humphrey Bogart's character, Rick Blaine.

'Here's looking at you, kid' – Blaine again.

And one of the most quoted AND misquoted lines of all time: 'Play it [again], Sam. Play "As Time Goes By"' – uttered by Bogart's co-star Ingrid Bergman, playing Ilsa Lund.

These sentences, especially Bergman's misquoted command, are simply snapshots of memorable characters, their significance appearing to expire once the exchanges end. In the case of *Casablanca*, the prolific success of the script sug-

gests a considered, studied approach to character building and plot formation. However, this could not be further from the truth.

Italian film director Frank Capra, who most famously worked on *It's a Wonderful Life* (1946), once noted: 'There are no rules in filmmaking. Only sins. And the cardinal sin is dullness.' This mantra rings true throughout the canon of cinema's classics. Each character affects the storyline; they all serve a purpose. Every line has a job. No pause is empty, all are pregnant. In the case of *Casablanca* this was a matter of necessity, rather than choice. As the film progresses, a fraught love triangle nears its conclusion. Ilsa Lund and Rick Blaine (Bergman and Bogart's characters) rekindle old

emotions, despite the presence of Lund's husband Victor Laszlo, played by another star of the time, Paul Henreid. The plot twists and turns as Lund changes her mind repeatedly amid turbulent circumstances.

The uncertain ending to the film proved to be one of the keys to its success, triggering years of discussion and reports of lost footage. It was even believed that a mythical alternate ending had been filmed – the basis for an episode of *The Simpsons* years later, in testament to the film's enduring influence. While there was no truth to this rumour, it was closer to the truth than many think. When speaking

about the film in his final ever interview, Howard Koch (one of *Casablanca*'s co-writers) shed some light on where the rumours might have arisen from. Koch recalled Bergman's queries during filming over how the film was going to end:

> Ingrid Bergman came to me and said, 'Which man should I love more?' I said to her, 'I don't know, play them both evenly.' You see we didn't have an ending, so we didn't know what was going to happen!

Even more surprisingly, this is how it remained until two months into filming. With a writing committee, as opposed to simply one or two collaborators, the film was very much a group effort which ultimately made each and every decision a matter of debate. They could, however, all agree on one thing – getting the ending right was crucial.

It was not the slickest of processes by any means, but the final production was impressive. It was a steady hit with audiences upon its release, bringing in $3.7 million gross revenue in its initial theatre run, but its stature has grown beyond all expectations over time. The core plot of the film was never in doubt; it was based upon a stage play that had yet to be published, by Murray Bennett and Joan Alison, called *Everybody Comes to Rick's*. But however strong the central plot may have been, it was not what made the film iconic. The elements of the film that have endured and improved with age, were left very much up to chance. It was the interactions between Bogart and Bergman, the sensational ending and the finer touches applied by director Michael Curtiz

that rendered the film an undisputed classic. So how close did *Casablanca* come to being 'just another movie'?

While it may seem a rather trivial gloss on a most accomplished production, the quotable lines that fill *Casablanca* have been an essential part of the film's long-lasting legacy. They ensured that it became and remained a cult classic. However, it was by no means the universal favourite it is today until Humphrey Bogart's death in 1957. As with so many artists before and since, the popularity of Bogart's most iconic role grew posthumously, with his cult following spilling over into the mainstream. The film unsurprisingly

enjoyed a period of resurgence in the immediate aftermath of his passing, with his most famous lines – invariably from *Casablanca* – filling the obituary pages nationwide. But it was in Cambridge, Massachusetts that the film began to really soar.

Home to the world-renowned Harvard University, Cambridge boasts many hubs of culture and intellect, none more noteworthy than the Brattle Theatre in Harvard Square. In honour of the late star, from the late 50s onwards the Brattle would screen *Casablanca* as the university year drew to an end. It became a firm tradition, with hordes of loyal fans turning up year after year, often dressed as characters from the film or era. The iconic lines were chanted in unison; on some occasions the entire film was recited word for word.

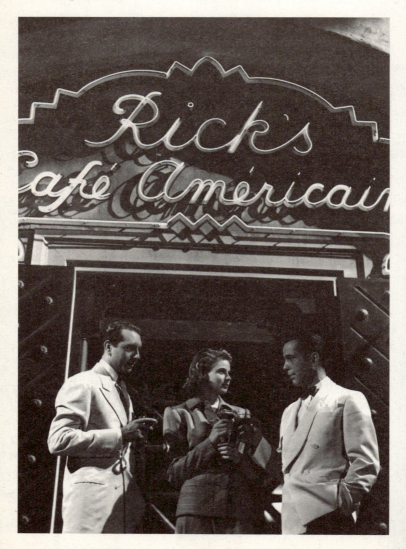

The attendees called themselves the 'Bogie Cult'. Before long the cult movement had spread south to New York City and, more remarkably, across the Atlantic to France. Few could have foreseen such a revival in popularity.

Prior to the Bogie Cult, Humphrey Bogart was by no means an unknown. He had famously helped to establish the prestigious yet unofficial social group known as the Rat Pack. The group saw him keep regular company with Frank Sinatra, among others, and after his death came to include musical entertainers Sammy Davis Jr. and Dean Martin, forming the bedrock of America's illustrious jazz scene. The Rat Pack afforded Bogart fame by association, his stock rising due to the well-known company he kept, whereas in the case of the Bogie Cult the adulation was all for him.

Since it was *Casablanca* that sparked the resurgence in Bogart's fame, it could be seen as somewhat unfair that it was not 'the Cult of Bogie and Bergman'. However, it seems that Bogart had always been the prized asset; it later emerged that the studio, Warner Brothers, had taken out a $100,000 life insurance policy for him during filming. Bergman's role in the film, although far from insignificant, was in essence a supporting role. It is not without reason that Bergman's most memorable line is often misquoted; all the show-stealers were left to Bogart.

However, had there been a more regimented approach to filming he might have been robbed of one of his, and indeed the film's, most memorable moments. The immortal line 'Here's looking at you, kid' does not appear in any of the initial scripts. Instead, the line 'Here's good luck to

you, kid' can be found. It was more clunky and lacked the effortless cool of its replacement, and Bogart made the decision himself to change the line. The revised line is spoken several times but most poignantly when Rick is saying his farewell to his love, Ilsa. Delivered as a toast in the film, it is believed to have originated from the games of poker that the two stars played on set, with 'looking at you' a popular term for when a player is holding 'face' cards, such as kings and queens.

And the tidy-up operation that was performed on the script did not end there. Rick's 'Of all the gin joints ...' line was initially about a café, but came to be similarly infused with Bogart's stylised vocabulary. Of course 'Here's good luck to you, kid' and 'Of all the cafés ...' could also have gone on to become classic quotes, but little touches like these were applied across the entire film, and the sheer volume of small but crucial elements that hung in the balance suggest the finished product could have been very different.

Similarly, the film's soundtrack and yet another of the film's key moments hinged on a haircut. In the 'Play it [again], Sam' scene, Ingrid Bergman's character implores Sam, a pianist played by Dooley Wilson, to give a rendition of 'As Time Goes By', a song by Herman Hupfeld. The film's score composer, Max Steiner, had prepared a self-penned replacement melody, as he felt the Hupfeld song was too simplistic for such a complex film. Yet by the time Steiner suggested re-shooting the scene Bergman's hair had been restyled for her role in *For Whom the Bell Tolls* (1943), a film she was shooting alongside *Casablanca*. For little more than

the sake of continuity they opted to stick with 'As Time Goes By' and just as well, since in 2004 the American Film Institute placed the ditty second in their top 100 film songs. In December 2012 the piano which Dooley Wilson played in the scene sold for $600,000 (£370,000) at auction.

While these tweaks were almost accidental, the decision about the film's ending was anything but. Months of debate and discussion saw a multitude of possible conclusions bandied about, each carrying the potential to completely alter the tone of the film. As *Casablanca* draws to an end there are a great number of loose ends waiting to be tied up. With the

love interests of three separate parties at play there would inevitably be a degree of sacrifice or heartbreak, but what remained to be seen was who would lose out. Part of the success of the studio's chosen ending is due to the fact that it gives little explanation as to why the characters make the choices they do. Bogart's Rick refuses to compete for Bergman's Ilsa any longer, as he helps her and her husband to escape from the onrushing police. The viewer's sympathies have been with Rick throughout, so this comes as a bitter-sweet blow. Although Ilsa Lund is married, Rick is always portrayed as her true, passionate love. The subtle gestures

exchanged between the characters, the fact that Rick says his farewell to Ilsa while her husband Laszlo is present, even the fog that surrounds them on the airport runway; these elements combine to make a fantastically frustrating conclusion that shows the audience very little. It is open to endless interpretation, something that has brought audiences back time and time again as they attempt to work out exactly how and why it ended as it did.

The film's finale hinges on a line spoken by a corrupt official, Captain Renault. He witnesses Rick murdering a Nazi major, and when police arrive on the scene there is a moment of great uncertainty as the viewer waits to find out whether or not he will turn Rick over to the law. Much to the audience's surprise, he commands one of his subordinates to 'round up the usual suspects', allowing Rick to go unpunished. It is yet another fantastically well-chosen line that came almost by chance. It is widely believed that the key line was scrawled out on the bonnet of a car on set, having come to the writers in a moment of inspiration. The fact that Rick escaped arrest following what was fundamentally an act of noble sacrifice somehow makes the ending more palatable. It offers the hope that all is not over for him.

Other possible conclusions to the film were discussed at length, but many of them were hampered by tight restrictions imposed by the Production Code of the day. The Production Code is the industry-wide set of rules and regulations that has to be adhered to, or at least appear to be, and so had a definite say in the high-profile final scenes. The resolution that many in the audience will have been

rooting for, to see Ilsa leave Laszlo for Rick, was simply not possible. Studios were prohibited at the time from depicting adulterous actions so this would never have been an option. However, one possibility that was seriously considered was a scenario in which Victor Laszlo is killed, as at the time of his escape he is being chased by crooked police for a minor charge. This would have left Ilsa and Rick free to rekindle their relationship. However the producers ultimately rejected this conclusion as too grim, fearing that the viewing public would have been put off the happy ending by the uncomfortable circumstances which would have surrounded it.

So many last-minute changes combined to make the film an undisputed hit. Few movies have become so embedded

in popular culture as Bogart's classic, which is why so many later filmmakers have studied it in an attempt to decode the formula for success. For those studious artists the most frustrating realisation of all is that there is no formula; it was the result of sensational on-screen chemistry and a wealth of brilliant interventions.

Imagine that...

The Pathé brothers stick to audio production ... and film journalism remains an unrealised industry

Much has changed about the cinema experience in recent decades. The rise of the multiplex has ushered in eye-watering prices, 3D glasses and reclining chairs. The merits of these new features are the source of much debate, but more significant are the elements that have had to make way for them. 'B movies' – traditionally the lower-budget, lower-risk half of a double feature – were the invaluable testing ground of budding filmmakers yet have faded from the cinematic landscape, only really remaining in tandem with animated films. Audiences no longer stand to sing the national anthem after a film has finished. Cinema has become an altogether more clinical medium, battling hard to remain relevant in the era of TV and the internet.

Predating John Logie Baird's first workable television,

cinema enjoyed an unopposed monopoly on visual enter-
tainment for around three decades. One company in
particular capitalised early on the opportunities which
accompanied the technology and the large audiences it
provided. In 1894 two French brothers, Charles and Émile
Pathé, decided that the time had come to extend their
business portfolio beyond their Parisian bistro. Known as
Pathé Frères (Pathé Brothers), or more simply Pathé, they
set their sights on musical entertainment; but almost instant
success meant that their plans soon grew bigger and bolder
than they could have imagined. They began by setting up a
gramophone shop, predominantly selling models produced
by Thomas Edison. Bearing witness to the ever-increasing
demand for Edison's devices, the brothers decided to try
their hand at production. They opened their own phono-
graphs factory and their reputation began to grow. Pathé
Records was formed but, far from contented, Charles' ambi-
tion was heightening with every success.

Within two years Pathé had transformed from a small shop
into a highly respected name within the industry, opening
recording studios in some of Europe's most desirable cit-
ies, the most significant of which began their prosperous
association with London. The success and resulting growth
of Pathé Records was so great that Charles and Émile were
compelled to call upon further siblings, Théophile and
Jacques. With more hands on deck Charles embraced the
opportunity to experiment further, using the brothers'
wealth of industry contacts and an ever-growing profile to
engineer a bold step into the world of motion pictures.

A remarkably studious approach to sound production had seen the brothers excel in the record business, and their emphasis on research and development was equally effective in the movie world. They began, as they had with music, firmly on the service side of the industry, although this time round it was clear that they would move into film production. Pathé film equipment and projectors led the market, and, with global expansion a priority, they continued to build upon their presence in London, which would eventually come to be their global base. In 1902 the first Pathé picture houses opened across Britain's capital city.

Their fleet of picture houses grew steadily over the next few years, and a period of development ensued as Charles formulated his strategy. The sector was still finding its feet as many companies, including Pathé, experimented in filmmaking. However, as others focused all their efforts on the production and improvement of feature-length films, the innovative French brothers spotted a gap in the market. The result was the birth of film journalism. By 1908 Pathé was ready to roll out its new concept into theatres, initially in their native France.

For the first time ever, as film fanatics arrived at their favoured picture houses, there was more on offer than just fictional tales and reconstructions of iconic events. Pathé's new concept, the newsreel, enabled customers to witness real-life footage of current events. It was a revolutionary idea, and unsurprisingly proved a huge hit with viewers. By 1910 the concept made its debut in British cinemas except, their confidence boosted by success in France, with far more

ambitious regularity. In fact, the brothers were so sure of its potential, they named their new cinematic subdivision 'British Pathé' – despite having an inescapably French crowing cockerel for its French logo. They initially presented the footage as *Pathé News* and each edition was roughly four minutes in length, with Pathé releasing two per week to begin with.

In Britain as in France, the filmic insight into current events was enthusiastically received and so Pathé responded with more content. They increased output to three newsreels each week, and these became an increasingly integral part of the cinema experience. Having read and heard

about news stories via newspapers and wireless, moviego-
ers then saw those events played out on the screen before
them. It engaged their imagination before the film had even
begun, helping them to suspend their disbelief. The escap-
ism it offered was unrivalled.

The popularity of Pathé's work continued to grow, espe-
cially during times of conflict. Coupled with the customary
rendition of the national anthem, wartime footage of the
troops turned cinemas into a hub of patriotism, a strong

pillar within strained communities. In turn, the demand for more footage spurred Charles Pathé and his colleagues onto better and bolder journalism. The output took on new forms including 'cinemagazines', which were longer than newsreels with light-hearted segments mixed in, as well as later producing full-length documentaries. Their ambitious expansion did not come without costs; financial difficulties threatened to cripple the company, leading to the sale of Pathé Records. The same fate eventually befell British Pathé as well, but by then the institution's journalistic values and operations were well established, setting it up for years of high-quality output.

The gamble taken by the Pathé brothers, branching out from audio production into the brave new world of cinema, paid off handsomely, at least in terms of their legacy. But had they stuck to the comfort of Pathé Records, as many would have advised, then cinema and journalism would have missed out on one of their greatest pioneers.

In the modern era of film journalism, there are so many competing forces that the loss of one institution would make little difference to the industry. The gap would soon be filled by its former competitors and things would quickly return to normal. However, when Pathé arrived at the forefront of British cinematic journalism there was no competition to ward off, and that is how it remained for

several years. Although newsreels seemed an obvious invention, given the new modes of communication that cinema offered, there was little pre-existing demand. Pathé created the demand as they went along.

This situation afforded the Pathé brothers an element of freedom that they had not found in other business ventures, yet they treated their work with an admirable sense of responsibility. When their coverage began it was simple and universally accessible. They dealt only with the most talked-about stories, due both to their concise format and the lack of reporters on their books. Expansion changed all of this.

Once Pathé increased the length and regularity of their productions, their fleet of reporters developed an uncanny knack of being in the right place at the right time. Sadly, this meant they were often in the right place at the wrong time too. On 6 May 1937, Pathé reporter William Deeke was sent to New Jersey on a filming assignment. He took position beside a landing strip and trained his camera on the skies in front of him in search of an historic aircraft. When it finally arrived in shot, his story took on a completely different dimension. The Hindenburg zeppelin, a large German commercial passenger aircraft, was concluding its second season of service and Deeke was on the scene to record the occasion. But when it came to land, disaster struck. The vehicle burst into flames, the outer shell of the zeppelin torn off by the blaze to leave the framework beneath exposed and illuminated. Deeke filmed the event, helplessly. Of the 97 crew and passengers on board, there were 36 fatalities.

On that day, Pathé were joined by three other film crews

including a budding young reporter called Eugene Castle. He too managed to capture the horrific blaze on camera and stood alongside Deeke, reacting to the tragedy with as much professional calm as he could muster. Yet Castle was not working for a major studio. His work was freelance and wholly inspired by Pathé. He proudly referred to his footage as a 'Pathegram' and it became the first production in a long line of works for his burgeoning 'home movies' company, Castle Films. This was just one example of the deference with which the industry's also-rans greeted Pathé.

As well as progressing from reporting the news to capturing it, Pathé began to raise more uncomfortable issues through their coverage. In particular, they championed women's rights when many other reputable institutions in print and radio chose to edit such thorny matters out of their reporting. However, Pathé set the agenda, championing the cause and allocating unprecedented levels of coverage to it. Their most significant contribution occurred completely by accident. Coming much earlier than the Hindenburg disaster, but also caught on film by Pathé's unsuspecting film crew, a moment of real tragedy in the British suffragette movement was recorded in 1913.

Emily Wilding Davison had been a member of the Women's Social and Political Union (WSPU) since 1906, joining Emmeline Pankhurst and many other women in their battle to redress the power imbalance within society. She showed a selfless commitment to the cause, sacrificing her freedom for the greater good as the suffragette cause turned militant. Her displays of defiance started off as relatively small

but visible outbursts, such as conducting arson attacks on public mailboxes, before later pelting the then prime minister, David Lloyd George, with rocks. Davison's role in the movement escalated when it became clear that small outbursts were making little difference. She was incarcerated in Strangeways prison for her attack on the PM and there set about causing as much disruption as possible, going on hunger strike and blockading herself inside her cell.

On 4 June 1913, she arrived at Epsom Downs racecourse in Surrey for the Derby Stakes race. It was one of the highest-profile horse races of the season with Anmer, the horse owned by King George V, among the runners. Naturally, for such a prestigious event, the nation's journalists had turned out in force. Davison and her fellow suffragettes recognised it as the perfect setting for a demonstration. She had been elected to carry out the deed, although to this day questions remain about her intended plan of action. She broke out from the crowd and into the middle of the racecourse, allowing a number of horses to pass her by. Based at the Tattenham Corner section of the course, Pathé were perfectly positioned to catch the whole incident on film. Davison positioned herself in front of Anmer. The two collided and Davison died in hospital four days later. The police investigation revealed that Davison had travelled to the racecourse on a return rail ticket, and that she had been carrying two flags emblazoned with suffragette insignia, fuelling the belief that she had not intended for the mission to be fatal.

The footage shocked viewers, confirming the sense in Emmeline Pankhurst's suffragette motto – 'Deeds not

words'. Whether or not it had been Davison's intention to collide with Anmer on that day, she was acting in the truest spirit of the suffragette movement. Her act would, however, have been deprived of much of its impact had it not been immortalised in Pathé's video archives. The newsreel footage was far more immediate than any newspaper report on the incident, or any film that succeeded it in the cinemas. It is just one of many momentous films in the Pathé archive, moments that helped change history via their cinematic exposure.

When, in 1970, British Pathé ceased to produce their newsreel footage, the decision to call time on such a historic series came as no surprise. There was no longer any need for it. People across the nation had access to news footage on a daily basis via their television sets, and it would be

more up to date than Pathé's newsreel. The one-time industry leader was now defunct. Yet without the work of Charles Pathé such competitors would not have even been able to approach the high standard of journalism that eventually rendered his company obsolete. Aside from Pathé's own journalistic legacy, of which their support of the suffragette movement was a particular highlight, they introduced a level of determination and focus that has been the bedrock of video journalism ever since.

The British Pathé archives today contain over 90,000 separate items of news footage, lasting more than 3,500 hours in total. Their influence can be seen across the entire spectrum of journalism and was partly responsible for the rise in cinema attendance in the first half of the 20th century; in the UK it rose by half in the years between 1939 and 1942. Pathé's input united the previously unrelated elements of film entertainment and serious journalism. They took the risks that others were too afraid to take, or that others were not even aware existed, to mobilise film journalism into becoming one of the most powerful and influential industries of the 20th century, and gave cinema a tremendous boost along the way.

Imagine that ...

Film trailers remain in the hands
of specialist companies ... and
the quality of cinema soars

It has often been said that there is no business like show
business, but at heart that's exactly what it is – a business.
Artistic and creative merit is rendered worthless if the
studio fails to package the film attractively enough to win
over the masses. In the early days of cinema, due to a far
smaller number of productions, the studio's main task
post-production was getting the film into theatres. As with
any major industry over the last century, cinema has had to
adapt to the technological advances that have created an
on-demand society.

In recent years, with the rise of home movie systems and
computing devices that allow users to view high-definition
video almost anywhere, film's prime domain has migrated
from theatres to the home. The movie experience has

changed and so too has its marketing. Free of the overheads incurred in running a cinema, online film distributors enjoyed a boom at the start of the 21st century, able to undercut their real-world competitors. In 2008 the UK Film Council conducted an investigation into the rising popularity of video on demand (VOD) and its effect on the film business. Video on demand is the term used to describe digital content that can be selected to view at any time either on a television or computer, differing from pre-scheduled television content. The study compared all the competing sectors in film media to assess the market share, and the findings made for compelling if unsurprising reading. DVDs had secured over half of the market, 44 per cent coming from DVD retail and a further 7 per cent coming from rental. Cinemas, having once held an undisputed monopoly, now held only a fifth of the market. However the figure that the UK Film Council was most interested in was that for VOD and nVOD (near-video-on-demand). Of the £4,227 million gross revenue generated by UK film in 2007, £153 million came from VOD and nVOD. Despite holding a meagre 4 per cent market share, the sector was showing signs of rapid growth, having only really come into being a couple of years earlier.

Fast forward a few years and film studios find themselves having to alter their strategy as VOD eats further and further into the market, rapidly nearing a share to rival theatres and DVD/Blu-ray. As a result, it has come to materially affect the way in which cinemas operate. While the majority of films still debut there, the period of exclusivity they enjoy

is decreasing year on year. Previously this 'theatrical window' lasted as long as six months, allowing films to almost exhaust their potential viewership before being sold on in the form of video and later DVD. However, the rise of VOD 'premiere' services has shortened this period and in some specific cases even encroaches upon it, with a number of subscription services screening films in the closing weeks of their theatre run. It has reshaped the marketing approaches of studios across the globe, forcing them to embrace new ways of engaging their prospective audiences.

The effect of such a diversified marketplace is that the way in which a film is packaged becomes absolutely crucial. With viral videos, merchandising, social media and extensive promotional tours, these days almost as much effort and planning goes into selling a film as producing it. It's a far cry from the early days of cinema when films stood alone, promoted by little more than word of mouth. The transition was first sparked in 1913, by a Swede working in the Winter Garden Theatre on Broadway. Nils Granlund had been busy experimenting with promotional techniques in the world of vaudeville when an enterprising young theatre owner enlisted his services. Marcus Loews, the man who later co-founded Metro Goldwyn Mayer, ran a theatre chain at the time and had been alerted to Granlund's talents by an eye-catching promotional tour he had arranged for a vaudeville production called *Hanky Panky*.

Hired by Loews at the end of the *Hanky Panky* tour, Granlund's first significant act benefited another stage production. He constructed a short promotional film of backstage

interactions and rehearsals of *The Pleasure Seekers*, a musical play that was appearing on Broadway, in the hope that it might tempt audience members into attending a performance. Buoyed by the response to his promotion, Granlund began work on a second, more daring project. The market-

ing of *The Pleasure Seekers* was a local project intended to benefit the surrounding entertainment community, whereas the focus of his next project was a global personality – Charlie Chaplin. Granlund created a very basic slide-based film to alert cinemagoers to Chaplin's newest film. Although the

production only aired in Loews theatres, the combination of a bold new approach and one of Hollywood's hottest prospects saw America's film studios take notice.

Significantly, Granlund was working on behalf of the Marcus Loews theatre group rather than Chaplin, so the film was promoted at the theatre's expense. However, before long Paramount became the first film studio to follow in the footsteps of the New York theatre chain. Naturally, they began by only releasing promotional content for their most anticipated and highest-budget films in an attempt to reduce the financial risk. Yet unlike Granlund they lacked any real sense of purpose, creating film previews simply because it seemed like a good idea. This led to a confused approach with the previews being shown at the end of the feature film, rather than before it. Even though they were later subject to universal reordering, because the short promotional films came after the feature they came to be known in the business as 'trailers'.

As a result of the hesitancy with which film studios approached the new advertising tactic, a gap in the market arose for companies specialising in trailers, offering their services to theatres and studios alike. One company in particular cornered the market. They went by the name of the National Screen Service (NSS). The official-sounding organisation provided a professional, uniting presence in what was a rather disjointed environment. Over the next couple of decades the NSS came to dominate the business, taking the burden of advertisement off the studios' hands. Throughout the 1940s, having expanded to incorporate

movie posters and other assorted marketing methods into their service, the NSS managed to get America's biggest studios to sign exclusive contracts with them. They were unrivalled, and the filmmakers saw no problem with outsourcing the laborious task.

The status quo was harmonious, with the NSS helping to keep the film industry's profile high without going to excessive lengths. The trailers were kept simple, intending only to give a better understanding of the film's content so that viewers might be enticed. However, in a business filled with so many egos and so much ambition, harmony could only ever be temporary. By the early 1950s studios started to recognise the potential in marketing that they had previously failed to see, and so the unrelenting breakaway began. The audience's relationship with cinema was set to change forever, leaving purists to wonder what might have been if film trailers had remained an afterthought.

Movie trailers, previews, promotional films – whatever you prefer to call them – have evolved as much as feature films have over the last half-century or so. After decades on the periphery they have morphed into miniature epics, as painstakingly crafted as the projects that demand them. When studios began to reclaim their promotional duties from the NSS, the first thing they did was to up the ante. The modest simplicity of clear text and unedited shots was

M-G-M
PRESENTS

THE MASTER
OF SUSPENSE
WEAVES HIS
GREATEST TALE

IT'S A DEADLY
GAME of "TAG"

AND CARY GRANT
IS "IT"

HITCHCOCK
SUSPENSE

EVERY STAGGERING
SIGHT AND SOUND
IS REAL

ALFRED HITCHCOCK'S
NORTH BY
NORTHWEST
AN M-G-M PICTURE

CARY GRANT
EVA MARIE SAINT
JAMES MASON

IN **ALFRED HITCHCOCK'S**
NORTH BY NORTHWEST
© MCMLIX BY LOEW'S INCORPORATED

CARY GRANT

EVA MARIE SAINT

JAMES MASON

IN
THE MAGNITUDE OF
VISTAVISION
AND
TECHNICOLOR

THE M THAT
ONLY THE DE OF
VIS BIG THEATRE ON
SCREEN
A CAN BRING
TECH YOU! OLOR

replaced by bold, brightly coloured exclamations daubed across the screen. In retrospect the brash, excitable style of 1950s trailers can seem almost laughably heavy-handed but at the time their effect was anything but. The films of Alfred Hitchcock in particular suited the frenzied previews; they concentrated the tensions and shocks of more than an hour into a couple of minutes. In the case of horror films it was ideal. Whereas the old approach to trailers saw moments picked out simply to inform, they now looked to shock, scare and entertain. It meant that films like Hitchcock's that relied on suspense could begin to start building anticipation well in advance.

Inevitably, with one genre benefiting so greatly from this shift in approach, many other films lost out. Slow, methodical dramas were suddenly at a disadvantage, especially if they relied on subtlety rather than explosive confrontations to build the atmosphere. Studios were forced to adapt to prevent film dramas from dying out. This saw the rise of excessive exposition. Trailers would show the conclusion to the film and leave audiences wondering how such a scene would be arrived at. It could be argued that it simply altered the role of the narrative, shining a fresh light upon the film for those who had witnessed the trailer, but nonetheless it signalled a drastic change of intent. The trailers were no longer there to inform audiences of a film that they might enjoy, but instead aimed to attract viewers at all costs – even to the detriment of the eventual viewing experience. It may have taken the studios a while to get to grips with the power of marketing, but once they had there was

no looking back. The evolution of film trailers in the 1950s was considerable but, compared to what would follow, it was almost insignificant.

Throughout the 60s and 70s studios found new ways of sprucing up those films that favoured a more patient, measured tone. Much like the distraction and sleight of hand of a skilled magician, films came to be knowingly misrepresented in their promotion, with completely absent plot elements being hinted at. It was shameless trickery. The editing of trailers also changed to suit these new underhand tactics. They became shorter, and the scenes within them were often featured out of sequence.

The studios had good reasons to market their films so aggressively. In the years after advertising returned to the filmmakers, the entertainment industry underwent a period of restructuring. Cinema was no longer alone, but had been joined by the ever-imposing medium of television. As more and more people obtained television sets, the task of film studios moved from simply informing the public what was on show to coercing them into watching their offerings. The ethics of filmmaking had been compromised by its new rival. Had such techniques not been employed – if the NSS's gentler approach to promotion had continued – then the teething problems experienced by studios could well have forced a number of film companies out of business. It was vitally important to maintain cinema audience figures during the rise of television, in order to ward off an exodus from the industry. In the eyes of the studios, minimal advertising was no longer an option.

THIS IS A STORY OF MEN, AT WAR... THE STORY EVERY SOLDIER KNEW, BUT NONE WOULD DARE TELL...THIS IS WAR AS YOU'VE NEVER

TELL...THIS IS WAR AS YOU'VE NEVER SMELLED IT... TASTED IT... SEEN IT BEFORE...

THIS IS THE RAW, NAKED FACE OF BATTLE...WHERE NOT EVERYONE IS A HERO...AND NOT EVERY GUN IS POINTED AT

JACK PALANCE

EDDIE ALBERT

LEE MARVIN

ROBERT STRAUSS

and Introducing WILLIAM SMITHERS

THIS IS WAR... STRIPPED OF EVERYTHING BUT *TRUTH!*

THE WAR STORY SO HOT

THE WAR STORY SO HOT *NO ONE DARED* FILM IT TILL NOW!

ATTACK!

IT MARCHES WITH THE HANDFUL OF GREAT BATTLE PICTURES! ATTACK!

ATTACK! AN ASSOCIATES AND ALDRICH PRODUCTION RELEASED THRU UNITED ARTISTS

The 80s and 90s saw further change, with the pre-film trailers taking up an ever-growing percentage of the times-lots allocated to movie screenings. In a world ever more conditioned to marketing, catchphrases and taglines took a prominent role. A film's central characters became carica-tures in an attempt both to endear them instantly to viewers and to aid merchandise sales after the film's release. Voiceo-ver artists were drafted in with increasing regularity. One artist in particular came to resonate throughout theatres with prolific familiarity. Known as 'The Voice' or 'Thunder Throat', the king of the voiceover was a man called Don LaFontaine. He was hired by Paramount to voice their trail-ers in the late 70s, but soon realised that working exclusively for them was stifling his potential. Working on a freelance basis, at his peak he was believed to have worked on as many as 60 promotions a week. Booming introductions such as 'In a world where …' and 'From the makers of …' made LaFon-taine one of the best known voices in cinema, despite hardly anyone knowing what he looked like. Most importantly, the voiceover work perfected by LaFontaine gave trailers a more universal feel once more. The prominence of voiceovers replaced excessive exposition and led to far fewer mislead-ing trailers being produced, allowing a status quo to re-establish itself within the business.

Of course film marketing is still aggressive – after all, it is an inherently competitive industry – but today it is far less manipulative and insincere than it once was. The tech-niques that were deemed necessary throughout the 60s and 70s, despite working for the good of the industry as a whole,

sullied the purity of filmmaking. When trailers appear misleading today, it is for a different reason. The emphasis on marketing means that campaigns begin long before the filming of the feature has even concluded. With the final cut months away, directors hand over scenes and footage to the trailer producers without being certain that it will all feature in the eventual film.

In the case of 2012's thrilling drama, *The Master*, those who saw the previews and then the film could be excused for questioning whether they had gone to see the right film, such was the disparity in content. The film focuses on the experiences and coping strategies of a war veteran played by Joaquin Phoenix and is laced with subtlety, with much of the character's thought process left to the audience to decode. As a result, each and every shot is important. But the film's promotional content, which began to air before filming had finished, featured numerous scenes that never made the final cut. Phoenix said of director Paul Thomas Anderson: 'Paul will write many, many scenes that won't make it into the movie.' This scattergun approach provides the director with the largest possible choice of scenes, and in turn a larger number of storytelling tools – but it created a glaring disparity with the trailer. While it was purely accidental, such an incident casts a degree of doubt over the integrity of film advertising even today.

The many facets of film trailers mean that their contribution to cinema is a mixed blessing. On one hand, they helped the medium to continue to appear relevant and fresh in the face of strong competition; yet the abuse of trust

has seen many films enjoy commercial success that might otherwise have failed. Trailers have altered the relationship between viewers and storylines, diluting the work that is often so painstakingly crafted by directors and actors. Had advertisement been shunned as the compromising element that it cannot help being, cinema would undoubtedly have been forced into industry-wide downsizing, but the quality of its productions would arguably have improved as a result. With less money invested in promotion, and as a result less money coming into the business overall, film might have remained an industry fuelled solely by passion, rather than wealth and celebrity. Without promotional campaigns to alter a film's status and image, filmmakers would have retained the power they once had instead of exposing their plots and shocks to rake in more ticket sales.

Imagine that ...

Health and safety lapses decimate the cast of *The Wizard of Oz* ... and production is cancelled, much to their benefit

American actress Margaret Hamilton was and is better known to millions as the Wicked Witch of the West. She struck fear into the hearts of children in her role as the shrill, green-skinned demon in Metro Goldwyn Mayer's classic, *The Wizard of Oz* (1939). In fact, the terrifying incarnation that appeared on the final take was a toned-down version of the character, after a number of children had to be removed in hysterical fear when she appeared in front of a test audience. As a result a number of her more vicious lines were cut from the movie so as to slightly soften her image.

Nevertheless, to many she became indistinguishable from the witch, children drawing an immediate association upon spotting her. Observing the lasting effects of the movie, in

later years she said: 'The picture made a terrible impression of some kind on them, sometimes a ghastly impression, but most of them got over it, I guess.' It was an uncomfortable and unlikely position for Hamilton to find herself in, having begun her working life as a kindergarten teacher. She tentatively entered the acting profession in 1923 in her early twenties, gracing the stages of Broadway before eventually entering the movie scene a decade later.

Hamilton's cinema debut went some way towards type-casting her for the type of unglamorous roles that would eventually land her the part of the Wicked Witch, playing the very minor part of an orphanage worker in *Zoo in Budapest* (1933). In the same year she also appeared in *Another Language*, playing a slightly larger role that she had already performed on Broadway. Making multiple films in one year became the norm for Hamilton, who always worked on a freelance basis as opposed to signing restrictive studio contracts like her peers. This decision increased both her income and her profile. Over the next few years she rose steadily within the movie industry, making accomplished appearances in various supporting roles while continuing with stage productions.

Somewhat surprisingly, considering how synonymous the two have become, Hamilton was not the first person to be cast as the Wicked Witch. Whereas Hamilton wholeheartedly embraced the gruesome image of the character, her predecessor, Gale Sondergaard, withdrew when the alluring character she had agreed to play took on a less desirable look. Sondergaard had worked hard to appear glamorous

on film throughout her career and was afraid that the role might shatter this image. Although the decision proved to be the beginning of the end of her career, her fears regarding her image might not have been quite as ridiculous as many thought. There were a number of physical side-effects to playing the Wicked Witch of the West. For weeks after she had finished filming, Margaret Hamilton had a greenish hue, the tinting product required to achieve the witch's distinctive complexion having seeped into her skin. This was, however, a minor inconvenience when compared to earlier events on set.

One of Hamilton's most memorable scenes sees her attempting to intimidate Dorothy (played by Judy Garland) and her foil, the Good Witch. 'I'll get you, my pretty, and your little dog too!' she utters before exiting in a puff of orange-red smoke and a burst of flame, seemingly into thin air. Her vanishing appears seamless and the scene ends. Of course, there was more to this than met the eye. In an age

before computerised special effects and imagery, the trap door was king. Upon finishing her line, Hamilton's stage instruction was to take her mark behind the billowing red smoke, whereupon the trap door would activate and the work of the pyrotechnic department would signify her exit. However, on one occasion during filming all did not go as planned. She had finished her lines and arrived at the mark without faltering, but there was a glitch in the mechanism. The smoke puffed out, but the flames came too soon. By the time the trapdoor kicked open she was engulfed in flames. 'I was told to bend my knees and I'd land simply but suddenly I was in flames,' she later recalled. What's more, the copper-based face paint fuelled the blaze, so her skin remained alight.

Her livelihood was at stake, not to mention her life. When she was finally extinguished, she had sustained second- and third-degree burns. Extensive treatment was required to restore her skin, keeping her off set for six weeks. Yet, despite Hamilton being completely blameless in the incident, MGM made little effort to appease or care for her throughout her ordeal. The studio paid for her medical bills but not without a fight, and when she returned to the set their treatment of her was unsympathetic. Her face and hand had been badly burned and had to be covered with make-up and gloves. She was understandably hesitant to throw herself back into the stunts and pyrotechnic side of the production, so she insisted on a body double wherever possible.

Scandalously, the studio's slack health and safety regime continued throughout filming. Hamilton suffered no fur-

ther injuries, but other cast members did. For a production that eventually became one of the best-loved family films of all time, the sheer number of hazardous incidents that could have put an end to filming, or worse, is most alarming. So many lapses in professionalism risked seeing the film go down in history for reasons of tragedy rather than entertainment that it casts a dark shadow over the film's otherwise rosy image. So just how close was *The Wizard of Oz* to disaster and what might it have meant for the world of film?

Of all the possible outcomes on the hazardous set of *The Wizard of Oz*, one seemingly common-sense conclusion was never likely to occur – a lawsuit. The reason for this was also the cause of Hamilton's battle to receive financial support following her injuries: namely, that the studio held all the power. The financial structure of Hollywood was vastly different in the 1930s to the present day. Even though Hamilton had nominally opted out of the system, she was still at the mercy of the industry's giants. The majority of actors and actresses were recruited by the studios as company performers, as opposed to working on the film-by-film basis that Hamilton did. This meant that large studios could afford to be less than accommodating as they already had their stars tied down by lengthy contracts. Hamilton's agent, aware of the power imbalance, advised her that a lawsuit would leave her out of pocket, with a very powerful enemy

in MGM and a strong possibility of being blacklisted by the entire industry for trying to disrupt the system. Litigation was simply not an option. Her freelance status meant that technically she would be able to attempt to find work elsewhere, but since MGM had all the biggest stars, and consequently the best films, it would at the very least place a ceiling on her career.

Her co-stars, those actors and actresses on MGM contracts, had even fewer options. When Hamilton refused to participate in stunts after her stint in hospital, she was not risking demotion in the studio's future films. Her relationship with the studio was finite; however, that of her peers was not. The individuals selected to perform stunts on her behalf had little choice but to accept. Having been employed initially as a stand-in for Margaret Hamilton, Betty Danko saw her wages rise from $11 a day to $35 as a result of the extra work and its inherent risks. One of the visually impressive stunts she was required to perform, dressed as the Wicked Witch, saw her take to the skies on a broomstick. She was to be suspended in mid-air with a hollowed, broomstick-shaped pipe between her legs, which would emit smoke as she loomed overhead. Danko dutifully took to the air in her harness and filming began. Then, on the third take, the smoke billowed thicker and darker than before. The pipe exploded with Danko still suspended high above the set floor, torching her inner thighs as it did so. She faced a long spell in hospital, but later returned to finish the production.

The two life-threatening injuries incurred by Wicked Witches were the most eye-catching but by no means the

first to occur during the production – or the last, for that matter. Just a fortnight into filming Buddy Ebsen, the original Tin Man, was struck down by illness. The paint used to achieve his silvery, tin-like skin tone contained aluminium powder and, with every inch of his face painted, he inhaled great quantities of it. After nine days it began to have such a detrimental impact upon his health that he could no longer continue filming. Internally, the damage he had sustained threatened to kill him, his lungs coated in the harmful powder. It would be a decade before he was fit enough to return to the acting profession.

With injuries occurring set-wide and not simply contained to the stunt department, any number of casting alterations were possible. Hamilton could have been rendered incapable of continuing by her burns, which would have left Danko to conjure up a cackle to scare children for decades to come. Had the eventual Tin Man, Jackie Haley, been glossed with the near-lethal paint mixture then he too could have lost his iconic role in the film. This is all without considering the film's highest-profile name.

Playing the lead character Dorothy, Judy Garland's commitment to the film was tested by an experience as gruelling as that of any other actor on set. With more scenes than any other character in the film, she was stretched beyond the limits of her natural stamina. As Garland enjoyed increasing success in cinema, the demands on her increased as well. *The Wizard of Oz* was her seventh feature-length film and, at the tender age of sixteen, she was still enrolled in high school at the time. Nevertheless, her contract strictly stipu-

lated that her payment would cease if she became unable to continue filming at a satisfactory level, be it through ill health, loss of vocal capacity or any other factors. As such, Garland began to need chemical supplements in order to maintain stamina and performance levels. She filmed for long hours six days a week to ensure that the film could be produced in the allotted six-month window, a schedule that was far from unusual even in Garland's acting infancy. Once demand for her talents increased in the aftermath of _The Wizard of Oz_, she was prescribed Phenobarbital to control her appetite and Benzedrine to help her to wake up in the mornings. By the age of eighteen she was under the care of the famed psychiatrist of celebrities, Dr Frederick Hacker. His approach to treatment was heavily drug-focused. The concoctions grew stronger and more diverse as her career progressed, with new substances introduced to combat the side-effects of the others. She died in 1969, aged just 47 and at the hands of a near-lifelong battle with drugs and alcohol. It seems absurd to suggest it, but it might have been better for Garland if the film had been cancelled due to an unmanageable catalogue of injuries.

Garland was already recording another film in 1939, _Babes in Arms_, and would go on to film another three for release in 1940, and three again in 1941. It was an unrelenting work rate that continued for the rest of the decade. However, by 1940 she had finished school and was in a better position to proceed with such a demanding schedule. When _The Wizard of Oz_ was entering its most crucial phases of filming, her school career was coming to a climax too. Had her role as

Dorothy been cancelled or even just postponed to enable some of the stars to recover, this could have allowed her the vital time to acclimatise to the strenuous world of film. Just a year later she would have been free of the burdens of school and slightly more physically mature, able to cope with the exhausting nature of her work. Alas, she enjoyed no such rest period and the work took an ever-increasing toll on her health.

Of course, many people feel that the world of cinema would be a far weaker place without Dorothy's adventure with the Cowardly Lion, Tin Man and Scarecrow in tow. Despite the dangers it incurred, the film was an undeniable success. Judy Garland was immortalised by her role, with lines such as 'Toto, I've got a feeling we're not in Kansas anymore' repeated time after time in homage to her performance. Margaret Hamilton enjoyed the same iconic status, as did the rest of the cast's key performers. The storyline was aspirational: a faulty bunch of friends set off to tackle their personal demons, in search of courage, a heart and a brain. It was the perfect tale for instilling virtuous morals in youngsters, and did exactly that for years.

Hollywood would still have found a place for Dorothy and co. In fact it already had. The version that has come to be seen as definitive was not the first. Based upon the iconic children's novel by L. Frank Baum, *The Wonderful Wizard of Oz*, there had already been two silent movies based on the same tale by the time MGM, Judy Garland and Margaret Hamilton tried their hands at it. Both including the additional 'Wonderful' in their title, the first came in 1910

and the second in 1925. However, the latter version was hindered by the production company going bankrupt and distribution being curtailed. Nonetheless, L. Frank Baum's tale resonated so strongly, especially with film producers it seems, that a further adaptation probably would have appeared if the 1939 version had not come along and set such an unsurpassable benchmark. The wholesome tale could still have found its way into the houses of millions. What's more, since the likes of Buddy Ebsen and Gale Sondergaard – MGM's first choices – did not appear in the final production, it could be argued that they would have improved the film and reduced the need for compromise that eventually arose.

It is Hollywood sacrilege to say so, but there is a strong possibility that cancelling *The Wizard of Oz* might have been better for the film industry than finishing it. It might have helped to preserve the life and well-being of Judy Garland, one of cinema's greatest icons. Buddy Ebsen might have been spared a life-threatening battle with paint poisoning and Margaret Hamilton and Betty Danzo could have escaped without the horrific burns they suffered while filming – and who can say what they might have been able

to achieve subsequently? The film had a huge impact on the entertainment world, but the cost to its stars in pain and destruction was arguably even greater.

– THE FIERY CROSS OF THE KU KLUX KLAN –

D.W. GRIFFITH'S MIGHTY SPECTACLE

THE BIRTH OF A

NATION FOUNDED ON THOMAS DIXON'S 'THE CLANSMAN'

Imagine that ...

D.W. Griffith's *The Birth of a Nation* is banned following mass outrage ... and the future of film is thrown into jeopardy

One of the most troublesome distinctions in film criticism is that between influence and greatness. Since influence is such a desirable quality, it is easy to fall into the trap of thinking that it makes a film great. In many cases this is a harmless confusion however, but every now and then a film, book or creation will come along that is so distasteful, so incendiary, that its audience cannot accept its merits. In 1915, American filmmaker D.W. Griffith made a film that fell so violently on the 'influence' side of this dichotomy that Hollywood was unable to cope. His film, however praise-worthy for its innovative filmmaking and storytelling tech-niques, told a story so controversial that it sparked bedlam.

The Birth of a Nation begins before the American Civil War, as two families at the heart of the story meet. The Stoneman

brothers, hailing from the Northern reaches of the country, pay a visit to their friends in the South, the Cameron family. The two households are divided by the ongoing debate surrounding slavery – the Stonemans are pro-abolition unlike their Southern counterparts – and when civil war breaks out they are forced to join opposing armies. The film's narrative continues beyond the end of the Civil War, falsifying the post-war period known as the Reconstruction. While depicting characters from both sides of the dispute, the film is anything but even-handed – for a start, both families are white Americans.

Griffith's tale inverted history by portraying America's black population as the domineering oppressors and the whites as noble victims. He showed African-Americans as a disruptive and lecherous presence in the United States. One of the pivotal scenes in the movie sees Flora, a member of the Cameron family, pursued by Gus, a freed slave. He follows her into woodland and eventually to the edge of a precipice. As he moves nearer and nearer to Flora she opts to throw herself to her death rather than surrender to his advances. This example is typical of the film's beast-like portrayal of black people.

Although the film was released decades after the Civil War, race was still a divisive issue. Griffith's dogmatic approach incensed many while simultaneously reinforcing the views of others. The National Association for the Advancement of Colored People (NAACP) fought vehemently against the release of the film, making visible and vociferous protests at a number of its premiere screenings

across the nation. In an effort to educate audiences and would-be viewers on the film's inaccuracies, the NAACP circulated a 47-page pamphlet entitled 'Fighting a Vicious Film: Protest Against *The Birth of a Nation*.' The instant unrest it caused was a sign of things to come. Some cinemas took heed of the NAACP's concerns, but many of those who didn't sparked riots with their screenings.

The far-right Ku Klux Klan (KKK) embraced the film wholeheartedly. It even became a key part of their recruitment effort, as their membership grew following its release. There was also a noticeable rise in white-on-black attacks, with a number of murders directly attributed to the film.

Yet for all the ill feeling it created and the hateful message it imposed upon its audiences, it was an undoubted commercial success. In its opening year it grossed over $10 million, becoming the highest-grossing film to that date. The controversy accounted for some of this success, but not all; there were other reasons why people chose to see the film.

In 1915 cinema was still a silent domain, with the talkie not arriving until 1927 in the form of *The Jazz Singer*. A filmmaker's methods of storytelling were therefore somewhat limited, so whenever a new device or technique came along, people took note. In *The Birth of a Nation*, Griffith did not

just pioneer one or two new cinematic practices; the film was full of them. It was innovative in almost every respect; even in terms of length, as it became the first film to exceed the 100-minute mark. It was the first to use subtitles to complement the imagery, it was the first to use natural landscape as a backdrop and it was the first to use the technique of moving shots or 'panning'. By firing magnesium flares into the sky to provide light, it became the first film to feature a night-time shot. The use of narrative flashbacks was new, as were close-up and cameo-profile (medium close-up) shots. It was even the first film to fade or dissolve a shot at the end of a scene. It was quite simply the first cinematic production to take the form of a movie as we know it today.

It is therefore understandable that many liberal-minded individuals still openly argue the virtues of *The Birth of a Nation*. At the time it was impossible to separate the film's social stigma from its artistic value, but today it is clear that it is one of the most important films in history, not just for its on-screen innovations but also for revealing cinema to be the commercially viable industry that it has become. This dispassionate assessment has led many filmmakers and critics in the years since to refer to Griffith as the 'Father of Film'. Orson Welles once said:

> I have never really hated Hollywood except for its treatment of D.W. Griffith. No town, no industry, no profession, no art form owes so much to a single man.

Yet even with the passing of time it is still a highly inflamma-

tory film. As recently as 1995, the cable television channel Turner Classic Movies cancelled its scheduled broadcast of a remastered version of the film for fear that it would further ignite the racial tensions brought about by the O.J. Simpson murder trial.

Most films with the potential to cause the levels of controversy generated by *The Birth of a Nation* never make it to screen. The public outcry it faced would usually lead to censorship. If Griffith's film had been suppressed then the future of cinema would have hung perilously in the balance.

Due to its ambitious scale, *The Birth of a Nation* required a large crew. It was the first film to use mass crowds for battle scenes, and many shots were packed with extras to build a sense of the wider community. However, in the years after it was released, the list of contributors appeared to keep growing. The influence that the film later gained led many to exaggerate or completely fabricate claims of their involvement in the film.

No comprehensive records were kept of cast members, other than the named parts, and so the faceless extras and obscured stuntmen became a cast of thousands. It is difficult to refute many of the claims, although most are almost certainly fictitious, but there are many bizarre and high-profile examples that appear too opportune to be true. The most noteworthy is that of the esteemed and prolific

director John Ford. His extensive catalogue of works consists predominantly of Westerns and includes such classics as *Stagecoach* (1939), *The Grapes of Wrath* (1940) and *How Green was my Valley* (1941). The quality of these films is undisputed and Ford boasts an impressive array of awards. However, one conspicuously uncredited role sticks out among the rest. He is revered today as one of the greatest directors in history, with Orson Welles listing his three favourite directors as 'John Ford, John Ford and John Ford' and Alfred Hitchcock stating 'A John Ford film was a visual gratification'. It therefore seems almost blasphemous to question his claim – but it just seems so contrived.

As previously stated, Ford's role in *The Birth of a Nation* is not listed in the film's credits; but this was not unusual at the time, especially with such a large cast. It is the character that Ford claims to have played that makes it doubtful. In the 'Reconstruction' stage of the film, the Ku Klux Klan feature in a fast-paced scene. Riding into an African-American village on horseback, they wreak havoc upon the inhabitants. True to tradition, the Klansmen wear their distinctive all-white cloaks and pointed headwear. Ford claimed that his role in the film was as one of these Klansmen, specifically one of the few that had obscured their face, pulling 'his' hood down to shield against dust and debris. An actor might have subsequently distanced himself from such an inflammatory role, but for a director like Ford even the smallest part in the film would have raised his profile.

Regardless of whether or not Ford was one of them, *The Birth of a Nation* illegitimately launched many careers

throughout the movie business. To be able to say 'I was there' carried such gravitas within the industry that it became a qualification in itself, with directors hoping to learn from tales of the film's production and of working alongside D.W. Griffith. The sketchy nature of many claims of involvement make it impossible to identify just which actors would have suffered from a more authoritative list of credits, but it would doubtless have changed the casting choices for many of the films that came after it.

Other attempts to piggyback on D.W. Griffith's success were more justifiable. In 1916 Thomas Dixon Jr., author of *The Clansman*, the novel that was Griffith's inspiration for *The Birth of a Nation*, released a film of his own. Having

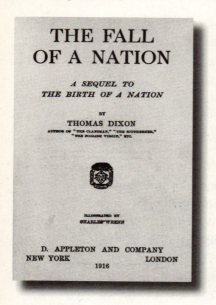

THE FALL
OF A NATION

A SEQUEL TO
THE BIRTH OF A NATION

BY
THOMAS DIXON
AUTHOR OF "THE CLANSMAN," "THE SOUTHERNER,"
"THE FOOLISH VIRGIN," ETC.

ILLUSTRATED BY
CHARLES WRENN

D. APPLETON AND COMPANY
NEW YORK LONDON
1916

missed out on the windfall that Griffith's adaptation had generated, Dixon decided to attempt something that had never been tried before – a sequel. *The Fall of a Nation* was based on his novel of the same name and used many of the same filming locations as the original, but failed to achieve anywhere near the same levels of critical acclaim. Focusing on America's lack of readiness for war as opposed to the racial divisions within the country, it was much less controversial and faded into obscurity as a result. Today there are no known copies of the film in existence.

Dixon's failed follow-up pioneered more than just sequels. He coupled his ambitious concept with a daring symphonic score written by Victor Herbert, something no other feature-length film had ever attempted. Film soundtracking was another area in which Griffith had led the way. For the premiere of *The Birth of a Nation*, the director had arranged for an orchestra to perform the score live in the theatre. Dixon thought he was going one better by including the score in the production itself rather than simply the live showings, a combination that was sure to get tongues wagging and audi-

ences queuing around the block. Unfortunately for Dixon, Griffith's experimental approach to directing was reflected almost immediately in the work of his contemporaries, while Dixon's innovations were lost in the crowd and only really noticed by his fellow directors.

Had *The Birth of a Nation* been banned then the effect would have been felt far beyond the world of cinema. Lives were lost as a result of the film, and the divisions it unearthed reached as far as the White House. Woodrow Wilson was president at the time of the film's release and, in one of the most misguided presidential decisions to date, scheduled a screening of D.W. Griffith's film in the historic building. This was very much a publicity stunt; it was a favour to the story's author, Dixon. The two had long been friends, even attending the same university. It only added to Wilson's already uncomfortable association with the film. He was even quoted in the film itself:

> The white men were roused by a mere instinct of self-pres-
> ervation ... until at last there had sprung into existence a
> great Ku Klux Klan, a veritable empire of the South, to
> protect the Southern country.

This quote was taken from Woodrow Wilson's book *A History of the American People*, and is wholly undisputable. He did, however, spend many years denying a number of further comments about the film that came to be attributed to him. According to these quotes he had extolled the film as a powerful truth, though many believe that they were

fabricated by the film's production team. With so much spin and counter-spin, as one might expect with the subject such a prominent political figure, it has become less clear over time what his actual words post-viewing were. As the uproar regarding the film grew to riotous proportions, Wilson felt compelled to release a statement dismissing the film as 'an unfortunate production' in an attempt to distance himself from the vitriol.

There is perhaps no better word to describe D.W. Griffith than controversial. No individual in the history of film has divided opinion so greatly. His ideology was clearly disturbed, but his methodology was quite inspired. It is no exaggeration to say that, as much as many people compartmentalise cinema history into two distinct periods – before and after the introduction of sound – it would be equally valid to draw the divide at *The Birth of a Nation*. Before Griffith's film, cinema was floundering. There was no guarantee that, without the film, the industry would even have persevered, as there had been no clear evidence until then of its commercial potential. So if his revolutionary work had been banned or even destroyed, it could have spelt the end for the embryonic world of film. Griffith not only pioneered the techniques to for making a great film, he also knew how to sell them.

So when Orson Welles berated Hollywood for its treatment of Griffith he was not doing so simply to be controversial, or to support the racist values his fellow filmmaker had spread so widely. He was merely offering recognition to the man who helped to make his own industry what it is today

– a sustainable, viable and, most of all, effective artistic medium. Without Griffith there might be no cinema.

**Other books
in the series:**

IMAGINE THAT...
THE HISTORY OF
MUSIC
REWRITTEN

MICHAEL SELLS

IMAGINE THAT...
THE HISTORY OF
TECHNOLOGY
REWRITTEN

MICHAEL SELLS

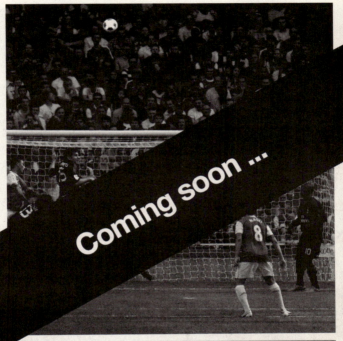

Coming soon ...

IMAGINE THAT...
THE HISTORY OF
FOOTBALL
REWRITTEN

MICHAEL SELLS

→ **INTRODUCING**

INTRODUCING GRAPHIC GUIDES

Covering subjects from Quantum Theory to Wittgenstein, Sociology to Islam and much more, the Graphic Guides use comic-book style illustrations to deftly explain humanity's biggest ideas.

'INTRODUCING is a small miracle of contemporary publishing ... Buy one now. Feel smarter almost immediately.' Don Paterson, *Guardian*

introducingbooks.com

facebook.com/introducingbooks